FORMLESS FORMATION
Vignettes for the End of this World

Sandra Ruiz & Hypatia Vourloumis

Formless Formation: Vignettes for the End of this World
ISBN 978-1-57027-381-0

Cover image by Yiannis Hadjiaslanis
Cover design by Haduhi Szukis
Interior design by Casandra Johns (www.houseofhands.net)

All images in this book by Yiannis Hadjiaslanis (www.hadjiaslanis.com)

Released by Minor Compositions 2021
Colchester / New York / Port Watson

Minor Compositions is a series of interventions & provocations
drawing from autonomous politics, avant-garde aesthetics, and
the revolutions of everyday life.

Minor Compositions is an imprint of Autonomedia
www.minorcompositions.info | minorcompositions@gmail.com

Distributed by Autonomedia
PO Box 568 Williamsburgh Station
Brooklyn, NY 11211

www.autonomedia.org
info@autonomedia.org

Contents

To the formless formations that are all the artists, thinkers, teachers, writers and soldiers who make this book possible; and to all our friends who carry us, in and across their different life forms, in these and other dimensions.

MOMENTUM

In *Soldier of Love*, Sade sings of how, at the hinterlands of devotion, she does her best to survive the "wild wild west."[1] Following a horn's plaintive range at "the borderlines of my faith,"[2] Sade's "Soldier of Love" arrives on the scene by moving from a sparse tinkle into the heft of a snare, a heavy off-beat bass cut by rustling drum rolls. Song and video unfurl, their ominous screeches and backbeats trouble militarized sonic and choreographic orders. Sade's call to arms, the fight to survive, to stay alive in the wild wild west, is to listen for the sound, to dance out a different formation with other soldiers. "I am love's soldier! I wait for the sound,"[3] she intones.

In a scene from another space and time, Flawless Sabrina stands on the bar of the LA club Silver Platter, a decades-long beacon for the Latinx gay, queer, and trans immigrant community. Ascending the bar, Flawless Sabrina celebrates, in a shout-out, the ways in which "the fist is still up!"[4] This insistent call from Wu Tsang's 2012 film *Wildness* echoes the collective stance and scene of the hoisted clenched fists and bowed heads that close Sade's 2010 music video.

As we write this, the abolitionist anti-fascist and anti-racist US rebellions of 2020 are unleashing a proliferation of coordinated dissent. Amid a pandemic, thousands and thousands of masked demonstrators charge the streets of cities, states, countries. Collec-

tive and singular signs, songs, street art, dancing, skating, chanting, toppling, vogueing, shouting, accompany raised fists across the globe, gestured by a vast array of staunch soldiers.

In rehearsing these scenes, the aesthetic-life-world (the inherent entanglement of aesthetics and politics) manifests otherworldly social compositions. For it is not incidental that life's momentum often mirrors art and art's momentum parallels life. These are the very stages of the everyday as the everyday is always staged.

Minor aesthetic performances stage chance convergences and divergences across formless formations. Formless formations relinquish the idea that one fulfills revolutionary promise by replacing one structure of power for another. Moving from reform to total abolition, ungovernable social swarms refuse to represent themselves in the name of anything but liberatory uprising. In abandoning its own legitimacy, the formless formation is the assembly of our obligations to one another.

What if our modern capitalist world system experienced its own demise, one enforced by a new social (dis)order motivated by those forming affinity against catastrophe? What if our collective momentum surpassed spatial and temporal confinement and gal-vanized revolution across overlapping differences? All structures have the potential to be abrogated and suspended from their organizing precepts, making form just a thing we do, not a thing we must follow.

Making form just a thing we do, not a thing we must follow.

Our *Formless Formation*, a thing we must follow, is composed of a series of borderless vignettes written for the end of this world. Each

vignette stands with the other, offering an opening for the minor voice to resound in otherwise form. Short suggestive narratives or accounts, or miniature images or portraits which fade into the mise-en-scene, vignettes reject the solidity of a frame. Particularly drawn to the second definition in its evocation of the *fade*, our formless formation visually echoes auditory resonance unbound by time, perspective, and perception.

In their surging motion, like rising and falling waves, forms shift, some visibly and others imperceptibly; for as you read, your eyes move: this inexorable visual and haptic movement is what creates legibility itself. There are perceived shapes to these vignettes, material forms in the spacing of words, syntaxes, silences, and the articulation of images and verses. To think of form as formless does not mean to emphasize a lack of form, but to unleash it from deterministic structure, to attend to form's momentum and its inseparability from other configurations.

The formless occurs in the in-between, the overlaps across the pulse and dissipations of communication, compositions of infinite parts and patterns lingering in assonance, dissonance, and resonance.

Only possible by way of gaps and encounter, resonance is found in the spaces it travels, occupies, and makes between chance meetings. Resonance's inherent transdisciplinarity breaks down the limits of individual subjects and objects, as well as fixed notions of time and space. It does this practically and materially as well as metaphorically, theoretically, and magically.

Resonance is the decibel frequency of (dis)harmonious amplitude.

Amplitudes of resonance are described by theoretical physicists

as the fluctuations of multidimensional vibration. Working in string theory (where dimensions within dimensions coexist simultaneously across many universes), Michio Kaku suggests that each universe can be thought of as a bubble that bounces, splits, and in consequence, creates a type of musicality. Each "bubble's membrane is a subatomic particle,"[5] representing a note on a vibrating string. This cosmic music resonates across an "eleven dimensional hyperspace,"[6] reverberating through the multiverse of universes. Some of these dimensions we are able to perceive, while others are only mathematically known. Floating over and around us and brewing beneath and within us, multidimensions are possibilities for new world orders.

Our vignettes are multiverses, hanging about even when we cannot see the residual spark and smoke from the atomic fire, from all existing matter itself.

Multiversal resonance relays in tandem, and the reverb causes a plurality of reflections across disparate dimensional formations. In acoustics, it is the augmentation of sound by reverberation when soundwaves from any sound source reflect off other surfaces in space. In physics, resonance occurs when one object vibrates at the same frequency of another object, propelling that second object into vibrational motion. Etymologically, resonance stems from the Latin *resonantia* meaning "echo," and from *resonare* "to sound again" or to resound. And the word itself reverberates across other meanings and fields such as in mechanics, crystallography, mathematics, and mycology and runs through music, noise, quotidian life practices, literature, astronomy, sociology, and chemistry. Resonance is also a signifier for the transmission of feeling, thought, senses, and memory. Moving between and beyond genres, media, disciplines, politics, and affects, resonance is constant tessellation and oscillation.

Yet resonance does not make for an easy and simplistic gathering of wholeness, for it is often a discrepant engagement; its movements through time and space are simultaneously integrative and disintegrative. Fissure, fracture, incongruity, the rickety — "the creaking of the word" — these practices inhabit discrepancy, as Nathaniel Mackey writes.[7] Discrepant engagements are necessary, for they reveal the ways in which "creative kinship and the lines of affinity it effects are much more complex, jagged and indissociable than the totalizing pretensions of canon formation tend to acknowledge."[8] Rather than suppressing noise, discrepant engagements acknowledge it. It is the "anti-foundational acknowledgement of founding noise"[9] and where we locate the noisy paradoxical encounters of discrepant thought, politics, social life, and sound; all conjoined, all congruously incongruous.

Such discrepant engagements also provide the avenue to the paradoxical incongruities built into Georges Bataille's antifoundational idea of *l'informe* (the formless), described in his surrealist art magazine *Documents* published in 1929. Through the creaking of words, the magazine sought to act as a "war machine against received ideas"[10] and as a direct challenge to the hierarchies and mainstreaming of art and humanism as exemplified by surrealist artists of the time turned commercial entrepreneurs. Bataille's suspicion and satirizing of form leads him to dismantle conventional form by valorizing the formless.

Formlessness, here, becomes a series of certain operations removed from modernism, refashioning both high and low culture and the opposition between form and content in art.[11] This is a necessary "attack on architecture"[12] as Bataille phrases it, on man, humanism. In his own counterattack, he offers an expansive meaning for the term formless: "It is not only an adjective having a given mean-

ing, but a term that serves to bring things down [*déclasser*] in the world."[13] In eradicating the architecture of high art, Bataille finds refuge in the underground as a sphere for art making. In staying down, in being down, one transfigures not only the meaning of the adjective as he shares, but the fundamental premises of artistic and social order.

The formless is a performative project, or as Bataille notes, "formless is ... a term serving to render *déclassé* the requirement that each thing have its own form.... Actually, for academic men to be happy would require the universe to take shape."[14] He adds: "on the other hand, to say that the universe resembles nothing and is nothing but formless is the same as saying that the universe is like a spider or a blob of spit [crachat]."[15] In acknowledging the philosophical potential of nothingness, he compares what could be seen as a void without meaning as living entity, a living mark, a living dribble, that in their own existences offer thought and create the infinite forms that make up a web of life. In other words, a spider, a blob of spit — seemingly meaningless actors — help establish a schematic democracy of entities, all brought down to the ground. Bataille equalizes all life through the nothingness and everythingness of universal formlessness.

Composed of multiversal resonating performances that constantly form and deform, the formless alters the content of design and the design of content. A fluctuating ensemble of operations, the formless performs borderless arrangements. These ensembles, for us, happen in and across the spatial-temporal continuums of anticolonial aesthetics that serve to bring things down [*déclasser*], for the anticolonial has always been lurking behind the categorical imperative of form itself, violent designs meant to be destroyed through aesthetic strategy, study, and battle.

Such critical study, battle, and deliberate aesthetic strategies are also elusive in form. In an interview for *Transversal Texts* titled "From Cooperation to Black Operation," Stefano Harney and Fred Moten argue that: "Study is not transformational. It is deformational, subformational, formless formation."[16] This is to say that the university can be sabotaged but never transformed by undercommon Black study and fugitive planning. Study, as a "mechanism of and for attunement,"[17] is not a critique of information, just as it is not a mobilization of critique as system building. Rather, study is a generative operation that is shiftless and aimless.

In a move away from cooperation to operation, because as they note, cooperation often leads to a "breakdown of being together,"[18] Harney and Moten think of operation as the gathering of oscillating social forms. In creating a "difference engine" or "making what you say sound like something,"[19] operation resonates with song's and poetry's capacity to blur dissensus and affirmation. This generative machine sounds out in ways that cooperation cannot in its breakdown and subtraction of a resonant being together.

As forever students, our vignettes resist the canons and separations of academic fields and read epistemic categorizations as the colonial structuring of university departments' need to shape, marketize, and control knowledge production. "The form" is too often a colonial construct that eviscerates options for multiplicity and the forms of formless plurality that exist in the evolution of ideas.

Thus, formal limitlessness has to do with questions of method, of doing, rather than knowing, of dismantling the epistemological elite, not upholding it. For as The Invisible Committee notes in *Now*: "what we need ... is precisely a continual creation of forms. It suffices to perceive them, to accept allowing them to arise, to

make a place for them and accompany their metamorphosis."[20] The anonymous authors call for the destituting of institutions and emphasize that the revolution will only happen through the encounter and collaboration of and between different social forms. Or as they note, "revolutionary movements do not spread by contamination but by *resonance*."[21]

If life, as noted above, is a constant metamorphosis of forms, how can we shift the ways we socially operate to allow for the avowal of their rising and falling change? By this we allude to forms that are actually perceived across their overlapping differences. While a seeming abstraction, The Invisible Committee lays bare the attributes of such forms by adding that "a habit is a form. A thought is a form. A friendship is a form. A work is a form. A profession is a form. Everything that lives is only forms and interactions of forms."[22]

It is in these "interactions of forms," that we see the accessibility of difference as vital to transformation in which convergence and divergence meet and equally depart according to inclined beat and rhythm.

Modelling her own beats and rhythms of interacting forms directly inspired by the findings of quantum physics, Denise Ferreira da Silva lays out a complex modernity informed by "difference without separability."[23] Thinking through questions of social difference and organizing by way of quantum physics' notions of non-locality and entanglement, Ferreira da Silva troubles the three "ontological pillars that sustain modern thought:"separability, determinacy, and sequentiality.[24] In her construction of elemental interactions, the world is a plenum where all life forms are indeterminate, non-local, and "without space-time"[25] in their enmeshment: "When nonlocality guides

our imaging of the universe, difference is not a manifestation of an unresolvable *estrangement*, but the expression of an elementary *entanglement*."[26] This kind of multiversal, multidimensional formlessness does not eradicate material difference, for all that makes up the shifting plenum is also at once singular.

To be formless, then, is to be in solidarity. It is to be open to options, and to be open to the option of *a future of the future* even if, and especially when, we can't see past the end of this world. What is at stake, according to Ferreira da Silva, as it is for us, is the end of the world as we *know* it. Or, as the band R.E.M. sang in 1987, "it's the end of the world as we know it" or like "a government for hire and a combat site; left of west and coming in a hurry; with the furies breathing down your neck."[27] These types of *knowing* are never separate from epistemologies that produce racial grammars, which is to say, modern grammars that simultaneously exclude and catch sight of minor voices.

Like the band, we feel fine knowing that this world is coming to a close and see *Formless Formation* as collective vignettes for new planetary practices of social border breakage: the necessary undoing of the political economy and its "terms of order,"[28] as Cedric Robinson shares; the end of this world as we know it on a global level if the fluctuations of different life forms are to survive and flourish (for formless formations bring instantly to mind the swarms of life in all their manifestations, most particularly more-than-human ones); the current findings that most existences (including ours) have only a few decades left on this planet according to recent climate change studies.

Although formless formations find ways to exist outside of the given terms of political and social order, such high stakes necessitate an

underlining of the *dispositifs* of the world as we know it. For natural disasters and pandemics are not natural, or supernatural agendas imposed on bad, inept, and indebted subjects, but rather symptoms of capitalism and colonialism. Instead of "punishing" subjects, Nature is responding to economic greed and aggression, where, for example, in the last couple of years alone, entire continents from Australia to Asia to Africa to Latin America have been on fire, under water, breaking in winds, and cracking at the earth's center. Take for instance the deadly hurricanes of Puerto Rico in 2017 and 2018 and the ongoing daily earthquakes of 2019 and 2020; the repeated colossal flooding in Jakarta, Venice, and Bangladesh; the disappearing islands of the Pacific and the Indian Ocean; a 20 degrees Celsius Antarctica and 30 degrees Celsius Arctic; Australia, the Amazon, and Equatorial Africa genocidally aflame.

At the same time, protest and rebellion persist across the world in mass uprisings from Beirut, Hong Kong, Haiti, Chile, France, Brazil, Iran, Iraq, Canada, Peru, Columbia to major cities of the USA. It is not inconsequential that from 2019-2020 those protesting the death cult of neoliberal economic policies are also faced with a roiling pandemic activated by the machines of extractive capital. The persistence of capitalism is the endurance of colonial profiteering under the rubric of global resource wars, their genocides perpetrated in the name of profit. In facing the staggering violence of our everyday we heed the words of Thomas Sankara, which remind us how "Debt's origins come from colonialism's origins. Those who lend us money are those who colonized us."[29] Our formless formation is a rally for resistance indebted to inseparable difference.

At the center of these vignettes sits the essential proposition that the anticapitalist is anticolonial and anti-self-approbative. Through shifting strategic coalitions and resonances that bypass

the nation-state's containing and expelling borders, the formless formation of sociality moves outside and across all spilling borders. Because "something that is constituted here resonates with the shock wave emitted by something constituted over there,"[30] the formless formation encompasses an agglomeration of multiple uprisings across planetary struggles.

Thus, these vignettes are a compositional folding into immeasurable improvisational passages always-already performed and shared. A sense and practice not granted, resonance is an operation we labor toward and arrive at together. And communicability in and across multiversal, multidimensional difference is a formless formation best illuminated via the poesis of aesthetic-life-worlds.

But what exactly is this aesthetic-life-world, and how do we find its formless operation?

The aesthetic does not merely index the beautiful, the visual, and its effects, all divided from sociality and culture, as Raymond Williams notes, but marks both the experience of sense perception and feeling.[31] Or as bell hooks suggests: "aesthetics is more than a philosophy or theory of art and beauty; it is a way of inhabiting space, a particular location, a way of looking and *becoming*."[32] The aesthetic imagines and manifests other worlds and pleasures, intimate and expansive senses of inhabitation and becoming across space and time. It evokes and re-imagines not only representations and judgments of beauty and taste, but the relational and intertwined bonds that form between objects, subjects, entities, histories, and narratives.

Advancing past the intellectual domain of the cultural elite, aesthetic-life-worlds move through and across cultural manifestations

informed by minoritarian life.[33] The aesthetic travels with and from visual practice to include the particularities of sound, touch, taste, smell, and the full sensorial capacities of the body. The aesthetic also challenges transparent representational norms of difference in both form and content. Just like "an insurrection is not like a plague or a forest fire – a linear process which spreads from place to place after an initial spark,"[34] the aesthetic-life-world "takes the shape of a music, whose focal points, though dispersed in time and space, succeed in imposing the rhythms of their own vibrations"[35] Echoing across terrain, the full vitality of the aesthetic is never removed from the worlds of struggle, abolition, and labor.

The aesthetic harbors both singular details and the interactions of forms of life, world, and politics, from the everyday to the everywhere. Released in the aesthetic-life-worlds of ritual, song, dance, music, literature, politics, and poetry, all arts and all cultures vibrate in and make up the plenum in their own variant "wild star-burst of metamorphosis."[36] Therefore, the enmeshment of the aesthetic and political is centered within its own entanglement of difference where although intertwined, the distinction between them honors their singular/plural internal logic.

In taking "cues from artists and dreamers rather than from generals, politicians, and other po-faced figures more commonly associated with the easier connotations of strategizing,"[37] Stevphen Shukaitis approaches aesthetic practices as implicitly containing plans for quotidian social action. Considering the ways that art, aesthetics, and activism inform each other, he argues that we can rethink strategy by attending to the conversation between artistic avant-gardes and autonomist political movements. For Shukaitis, this essential conversation refuses the separation between art and daily life as well as the cooptation of strategic art

by capital and modes of governmentality. Endeavoring to modify the domain "where strategy occurs as an ongoing socialized process,"[38] Shukaitis retraces aesthetic strategies that create spaces for activist organizing, for insurrectionary aesthetic forms, as shifting modes of quotidian strategy may outline "the compositions of movements to come."[39] At the same time, the uprisings of wild star-bursting aesthetic-life-worlds and compositional social movements must always, as Randy Martin contends, attend to a type of preemptive politics.[40]

This preemption is manifold and negotiates the ways in which social movements and aesthetic strategies may be co-opted and defeated if completely absorbed or appropriated by power. On the other hand, preemptive politics is also about sensing social movement, aesthetic-life-worlds, and civil disobedience as integrative and disintegrative formless formation, and thus, preempting their internal calcification and capture. This undulating "tidalectic,"[41] to borrow from Kamau Brathwaite's poetry, directs our sentiments, not by way of mere terror, but via the promise of the to and fro of aesthetics, all imaginations brimming against the limitation of their own freedom.

Such a tidalectical preemption also always keeps an eye on the ways that fascist formations are built upon aesthetic strategies and traditions as well. Capitalizing on certain aesthetics that precede and exceed its terms of militarized order, the fascist nation state imposes its own directory of resonance. This is to say that fascism has a revolving resonance that pulls from its own objectives, ones which violently work to fulfill a lethal program.

If the word fascism etymologically stems from an aesthetic symbol of an axe cutting through a bundle of wood, then the bundle, the

sheaf, is the formless formation. In a counter strike, the resignifying bundle calls for a radical connectivity across difference, warring against chronological fascist orders. Neither time nor space sufficiently augment our limitless capacity for inventive intertwinement, entangled not by ordering systems, but by resonance as mutual aid. Anti-fascist resonance is the condition of possibility for political organizing across difference, not for a programmatic utopia, but unruly revolt.

Unruliness doesn't abandon full structure; from the space of paradox and intricate tidalectical turns, the formless formation works from and against definition. For, many will ask, what is a formless formation? How can a form be formless in the process of forming something without or from form? How does this paradox open up possibilities for social organizing? The questions answer themselves: generative contradictions materially engender formless formation.

Take, for instance, the generative contradiction of the murmuration, where flying starlings swoop out a collective nebulousness contingent on intricate internal organizing. The murmuration's paradox lies in that it's magically shifting forms and shades depend on each bird coordinating with the seven birds nearest to it. Thus, combined movements for total coordinated change rely on small overlapping units of collaborative resonance. The manipulation of form is a conducing concert in which deeply listening is the new world (dis)order.

As the murmuring starlings express, formless formation is a practice and praxis; a principle of social organizing and direct action; an inherent solidarity; and the method of resonance. If this definition still requires a new sound order, we might imagine

listening to where the rhizomatic, the assemblages, affective and sensuous affinities, ephemera as evidence, discrepant engagement, and fugitive planning always-already break into lines of flight. In refusing "structuralization ahead of time,"[42] the formless formation's potential of touch and cut is found in contradictory configurations of fleeing flow. So, if asked more questions, like for example, where does one find this paradoxical yet material formless formation? Can one hold it? Is it practical? We would have to answer: "imagine touching dynamism."[43]

In conversation with an uncountable number of dynamic voices, the following vignettes echo across boundless ideas, thoughts, and feelings from artists and activists to revolutionaries and theorists. Never detached from the ensemble, our formlessness works to break through and build upon emergent sounds and strategies[44] while staying attuned to a potential "tyranny of structureless-ness."[45] Working across circulating sites of responsibility, rotation, re-distribution, diffusion, and access to resources, to name a few, the formless formation consists of practices of mediation across sonorous incitations and recitations in choric resonance and dissonance.

Formless Formation is an insurgent walking and flying side by side with planetary anticolonial organizing and in direct solidarity with all Indigenous, Black, Brown, feminist, queer, ecological, migrating, diasporic soldiers of love; imaginations and movements living and loving against, and in spite of, predatory capitalist forms and formations.

Sensed as both keenly acute and suffusedly formless, these agglomerations in and across difference *arkestrate*[46] multitudinous collaborations.

The formless formation resonating across discrepant aesthetic-life-worlds is the wild in the wild.

Fists up.

Wait for the sound.

SWARM

The swarm is a fragmentation in collective inhabitation, a transmission of social feeling and creative kinship, an affinity guided by the exquisite life and death of the aesthetic.

It is a sensual discrepancy, a creak, a split, a speculative history, an abstracted choreography. Wayward, anarchistic, an unordinary chorus, the swarm is an encounter, an entanglement, a diffracting enclosure releasing a string of light (a way out, a way in, a way to the elsewhere).

But the swarm is also riotous: subjects get vibrated out and brought back in, for the swarm is frequent and inhabited by its own frequencies. Because swarming harbors sound and carries the murmuration, it is a type of feedback, a gathering cadence, a rebellious composition, a formless formation in the form of a danced score.

A type of sociality in which the riotous unmute the silent, the swarm listens for dissonance, for the sonically deranged re-arrange us. It locates the brutality in a beat and enables the swarm to counter narrativity through exceeding communicability.

In the space between noise and sound, swarms refuse linearity, for linear time is both the syndrome and symptom of the singular

non-continuous. The singular non-continuous is soundless, not becoming, and never plural.

Chasing the future instead of waiting for it to arrive, the swarm soars in exodus. In developing a "storyless story," Vijay Iyer theorizes against the linearity of narrative and sound, and articulates a model and method that follow the contours of a swarming formless formation. Iyer argues that the consistent impulse "to tell a story" in jazz musicology presumes a chronological and "coherent" representation of the improvised solo.[47] If exodus necessitates explosion, Iyer ruptures narratives which ascertain that musical stories perform linearly, and not by "the changes themselves,"[48] within musical composition.

Considering a deeper understanding of discursive encounters within and between listening and playing, Iyer contends that performance is a "sustained antiphony"[49] in which sound and embodiment work together to shatter linear storytelling. In the "traces of embodiment,"[50] the body not only keeps the score, but engenders it. This is to say that the story created by the musician and listener is "not a simple linear narrative, but a "fractured, exploded one"[51] that extends beyond words and sounds. Bodies, like notes, chords, and intervals, reference one another, all working from both the listening ear and the "hearing body."[52] This is to also say that listening and bodily motion have similar neurological functions; as such the practice of music (its full sensorial evolution, from rehearsal to showtime, to the listener's movement in said time) is a "whole-body experience,"[53] occurring across musical verses in their sonorous forming.

So, if listening is about the bodily present-continuous, then it is also about the explosion of sound at the collapse of conventional narratological structure. If we know this to be listening, then *how*

does sound do its sounding? How does the structure of the story leave traces formed in formlessness? And if sound settles in the "trace of embodiment" what is the full property and potential of sound's swarming resonance?

Iyer discovers the resonance of this resounding within and outside the paralinguistic, in which the body's cognition conjoins the full scope of the aesthetic-life-world. For example, he notes: "many sophisticated musical concepts develop as an extension of physical activities, such as walking, strumming, hitting, cutting, scratching, or more figuratively, speaking."[54] Since this speaking can also be the breath outside the syllable, speech, too, must undergo a new listening time scale.

Like speech, "musical performance is a process," antiphonal, and formed via "semiotic dimensions."[55] The dimensional is swarmlike, for as Iyer adds, "sonic symbols"[56] refer "actively to other parts of the same piece, to other music, or to the contextual and extramusical phenomena – as with the rhythmic correspondences between the finger motion and speech itself."[57] Hence, "saying something" need not harbor the vestiges of narratological form, for in each utterance and musical iteration the listener helps to co-perform the piece, disrupting the temporality and signature of the story itself. In other words, the narrative not only explodes, but leaves remaining traces to be uncovered and followed; and these fragmentary traces speak in tongues, sounds, and bodily endurances.

Moving between "telling your story" and "keeping it real," in the name of "the athletics of black musical performance (or perhaps the performativity of black musical athletics),"[58] Iyer sees the creation of the changing story along the lines of Black social life and its ensuing labor. For as he notes, "what one hears is necessarily

the result of much effort, time, and process – in short, of *labor* (meant with all this word's attendant resonances)."[59] This here is the work of resonance, where sounds bounce off one another and the beat hits against beating bodily rhythms, all in a sonorous constellation of new social order – in which to work is to play is to listen is to cultivate new worlds.

Improvisational strumming and listening are like a swarming storm of motion in every limb that extends out and across. *Untitled Duet (the storm called progress)*,[60] a work by the movement-based performance artist boychild, in collaboration with dancer Josh Johnson and DJ and sound composer Total Freedom, labors to tell a story in the athletic process of keeping it real. A whole-body experience entailing techniques of improvisation, the performance seeks to undo and explode historical chronologies, linear narratives, and progressivisms. For boychild, "certain spaces call for certain durations."[61] Taking place in 2020 at the Gropius Bau in Berlin, a vast space with deep dark histories, the performance piece unfolds over five hours on two separate days.

This durational performance of ten hours in total is a reworking of Walter Benjamin's angel of history; a thinking with what he terms "the storm of progress"[62] *as* improvisation. While attempting to gesticulate outside regimes of power in an underground where legibility is disavowed, the performers' dance catalogues trauma, technology, scripture, and storytelling. Moreover, in asking her collaborator Total Freedom to think music *as* debris, boychild's and Johnson's performed motions and stillnesses in the storm called progress are inextricable from the ways sounds catalogue history.

Through two musical sets, these prepared improvisations of inter-twined sonic emanation and embodied movement become the

condition of possibility of one another, literally ripping each other to shreds. Both Johnson and boychild escape angels spotted in the light. Moving backwards, hair frozen but blowing in one direction, their movements become trapped in sincere glitches. Shrouded in clownlike, wide, and long billowing costumes of indeterminate historical period, they drag each other through and across propulsion and force. But their rigorous movements deteriorate from exhaustion against the hum of drones, obscured verbal language, illegible talking, possessed sound. In the similar operations of listening and bodily motion, *Untitled Duet (the storm of progress)* hauntingly swarms through the dark space and among the audience members.

"You have nothing left, so you dance," explains boychild.[63]

As the performance becomes more flayed and shredded, the space, audience, and the performers become increasingly embroiled; a storming enmeshment that alters the aura of the room and its history. This is not the imagining of touching dynamism; this is the touch of dynamism.

In a desire that unfolds with the audience, boychild's dance stumbles and breaks apart as she strenuously triggers electricity. Through an embodiment of circuits of hapticality, transmission, and physical and spatial reordering, boychild discharges nonlinear beginnings and endings. Her angled swirls limp, stretch in ordained slow motion and hyperspeed cracks, where in a pull of a shoulder or a gathering shudder, listening movements reach out from under the pit.

Everyone and everything dances, all matter generated from this magnetic field. For the swarm is not a social click; it's an opening, a flock, and a swarm of singularities.

A sensuous becoming that occurs within how one moves, lives and feels with others, such swarming surpasses identity, as José Muñoz notes.[64] For the author, this social opening is a magnetic field in which a Brown commons is enlivened against individual desire. Brownness "offers us a sense of the world ... represents a swarm of singularities" that exceed the "sole province of people who have been called or call themselves brown."[65] For Brownness is a liberating complication and a tangled uprising. It is "the sharing out of a brown sense of the world."[66] It is also a distributing energy that carries out to then drift in, through a choreography as overture for swarm.

As boychild performs in her collaborative work, it is also "a flowing into the common, that nonetheless maintains the urgencies and intensities we experience as freedom and difference."[67] Leaving resonant traces, glimmers, and passages in the world, Brownness is also the shared historical transience of dispossessed people. It is the illuminating and entangled vectors of the unshareable, invaluable, incalculable moments of connection that inevitably share out. A Brown sense of the world is where singularities swarm into a common unfolding fold and where when you have nothing left, you dance, and you dance together.

For Brownness is always a "shared sense of endurance"[68] between objects, subjects, dimensional planes that exist as much in how one *waits-on* with how one *waits-with* – a meeting point of political and aesthetic commitments figured into, within, and between enduring and constantly moving bodies.

Knowing no boundaries, no borders, the swarm moves out as much as it shifts in, a shareability invoking senses across direction and time. And this swarming shareability, a being together

as "an apartness together"[69] retains the building refrain of the aesthetic-life-world.

Marking Brown space by moving from aesthetic form to aesthetic practice across moments of shareability, Gayatri Gopinath builds an archive that also surpasses identity.[70] By curatorially tracing and bringing together indigenous and diasporic aesthetic-life-worlds, Gopinath points to how an abiding legacy of colonial modernity is its institutions of seeing that work to categorize and separate difference. Shedding light on the particularities of region via a queer curatorial lens, she suggests that the queer curation of swarms of singularities be understood as a type of "caring-for" and "caring-about."[71] Sustaining a "south-south relationality"[72] that bypasses and exceeds the nation-state and dominant visual fields, the aesthetic practices of queer diaspora undo measured space and time, displacing conventional rubrics of knowing, locating, and mapping. Through queer regional imaginaries and their encounters and collisions, transtemporal relays of affective relationality are unleashed between seemingly discontinuous and unrelated aesthetic practices.

Through this attention to curatorial affection as critical intention, curation reassembles the region to accentuate affinities across resonance – a gesture that understands the aesthetics of curation along political and ideological lines. By way of unruly visual practices, which include a bird's-eye view, or a cross-eyed one, or a reframing of frames, the parameters of staging sight and seeing are expanded. And by visually decentering the nation-state to understand movement, dispersal, and dispossession, Gopinath asks that one simultaneously see and sense affiliation between manifold aesthetics and entities.

Radical resonances trace lines of connective and unruly vibration across indigenous and diasporic regional spaces. Aesthetic-life-worlds, in other words, the aesthetic enactments of queer regions and diaspora, are performances of affiliated disorientation and suspension in their energy and excess.

The diaspora is a complete controlled chaos of swarm. Sometimes a storm.

As dispersions, scatterings, flights, and landings, storms of unruly regional and diasporic swarms are parts of things taken together through decentralized systems. Therefore, they must also, in turn, always exceed categories of seeing and mapping that mark divisions between human and more-than-human life-forms. Taking a bird's-eye view, for example, of echoing archipelagic formations that know nothing of nation-states, birds (like fish) form visions of formless collectives, flying and swimming ensembles. Waterward and skyward inhalations for life otherwise reorganized, groups of birds and fish are gliding communists, aerial and aquatic units that surrender the singular exhale for a communal horizontal inhalation. The birds and fish know when not to land, know how to watch and when to glide again. The choreography of these gliding animals swoop and sweep across borders, moved by their deliberate motions.

Forming structurally into moving groups like a congregation, shoal, gang, committee, parliament, herd, colony, party, bazaar, a glaring, murmuration, study, and the band, these planetary friends are in danger from, but quintessentially never tarnished by, the mystification of individual human want in a culture of poverty and dispossession. Units defined by gatherings of particular species, swarms are also flocks, schools, murders, assemblies,

teaching us that the delineations within the limitless swarm are in all interplanetary quantum matter, collective assemblies, and micro-biological existence. The swarm resonates in all life forms, from the most miniscule entity to how social life is organized among all sentient beings.

Maintained by colonial modernity's legacy of mapping and seeing, however, human directives of swarming acts of flight can become exercises in lethal surveillance. Contemporary militarized procedures in their choreographic routes identify the swarm that operates as a fugitive coalition, on the one hand, and on the other hand, the one that thrives as necropolitical warfare. The latter swarm is like a borderless formation of armed security circulating our atmosphere under the aegis of Empire and nation. Hovering and wavering over the sky since 9/11, national security measures extend their campaigns from conventional military intervention and bio-weaponization to "the armed drones of the near future"[73] in everyday routines.

In the name of the war on terror, these roving drones "are expected to resemble dragonflies and honey bees – an everlasting multi-species swarm of intel, misery, and sovereign power from above."[74] Performing their panoptic duty through aerial warfare, this example of the swarm patrols communities, towns, villages, regions, and nations – not to aid or cure the disenfranchised but to punish them. The US global security state and its allies, in this act of panopticism, carry out the neoliberal tactic of decimating the most fragile of life through the agency of surviving the fittest.

This droning dehumanizing design for organizing social order is not devoid, however, of counterinsurgency. Involuntarily, the global security state generates "new sensuous alliances and coa-

litions between groups of people who might have not previously seen themselves as allied with each other, or who might not have understood how they were involved in overlapping struggles against imperial policing, racialized punishment, and gendered militarism at home and abroad."[75] Despite the forever war across the Greater Middle East "radical diasporic affiliations and trans-national belonging"[76] are formed by transformational aesthetic workers. In figuring out the possibilities of collective and sensuous affiliation, Kapadia puts his finger on the resonating forces found across diasporic aesthetic-life-worlds, a kind of formless formation that vibrates global breath for reshaping the world.

The swarm is at times a simulation, a perception of the symbolic whereby reality is a model made hegemonically, copied and sustained by force. At times fragile, the swarm is a modulation, a resting point between charging forward and laying back. At other times, the swarm is a sensorial affinity between coinciding sites of struggle.

So, while a swarm may murder and incite grief, the swarm also erupts into revolution. With the flip of capital and the promise of a new labor power, the swarm recognizes their own dispossession, fleeing the scene of the crime into the space of abolition, where narratives explode and dancing together remakes historical precedent.

The swarm story leaves traces formed in formlessness, sounding and gesturing against the linear storm of progress and debris. For as boychild danced, her improvising shadow in the play of shifting light and sound startlingly revealed an intermittent trace of embodied wings.

From an angel's-, bird's-, or fish's-eye view, the swarm traces unforeseen and enduring embodiments. Across sensual affiliation

and exploding transtemporal relays of queer aesthetic-life-worlds, diasporic and regional commons counter colonialism's legacies of seeing, mapping, and droning. Swarming storms sustain rupturing antiphonies; sounding, gliding, and dancing out an "apartness together."[77]

Sometimes the swarm is a lagging type of brutality at the fade of both a slow death and an emergent beat at the precipice of unruly vibration.

Sometimes a swarm of singularities meet at the edge of profundity and the center of solidarity, for in murmuring trajectories, and changes *as* stories, the schooling swarm transports magnetic frequency.

The swarm is social resonance lingering in the interstices of forever.

Listen for the buzzing, the swaying, the cadenced tremors.

Follow the swarm into the beat of the sound.

VIBRATION

Everything, felt and unfelt, is held in motion. Invisible to the human eye, vibrational energy is both everywhere and everyone; its forces undulate in animating frequency. To vibrate-with is to resonate in emphatic and electrifying structurelessness, a formless formation that transmits a boundless series of actions. All motion reverberates in the interstices and excesses of existence, for to become is to also oscillate in the void's plenitude.

Listen for the wave beating and breathing across atomic seas. Sense the senses.

Contingent upon overflowing frequencies, both free and forced, vibrations swing and sway from disturbance to restoration into equilibrium. To vibrate is to be unclosed to encounter: the *how* of conjoining reverberations driven onward by vulnerable frictions and troubling tensions.

Listen for listening.

Vibration is a quivering wave, a sensing out across diverse magnetic energy that surpasses the logic of logic. To sense out is to also draw in, for the senses recuperate frequencies, fluttering dynamically to touch abundance.

Frequency's deepest beat is its capacity to deep listen.

A listening across space and time can be found in the domain of infinite details; or as Alexandra Vazquez contends, listening is an invitation to apprehend the "detail" or those moments of engagement when "wonderfully disruptive fissures" may "crack many a foundational premise behind all sorts of narratives."[78] Listening, then, is not about remembering, but about arresting the detail and being arrested by it.[79] In listening this way, one captures all apparent sonic disappearances: the silences, tiny sounds, gestural hums, ruptures, all the noise that is both (un)intelligible and thought-producing, for in the excess of sound one finds new pathways for a poetics and ethics of affinity.

Listening, for Vazquez, is a developmental and relational process: one listens in detail to also be heard, and to be heard is to have produced a sound to be listened to. Putting your finger on the evolution of sound means encountering the evolution of deep listening. And as Iyer shared previously, this evolution of sound is not necessarily a linear one, but best illuminated in the changing eruptions within composition, in the disturbance of narrative itself.[80] In this assorted choreography where the changes are the stories, sense's reverberations undo form by necessitating the desire for the vulnerable other, another that lends an ear as fervently as a spirit, both awoken and lifted by vibratory ambulations.

In her writing about groundbreaking composer Pauline Oliveros's idea of "deep listening,"[81] Julie Steinmetz also investigates the principles of "sonic relationality."[82] This praxis, for the author, is "a fundamentally relational act"[83] that begins by undoing the implied connection between hearing and listening. If listening

is an intensely "psychological act"[84] as Barthes contends, then as Steinmetz argues, "listening as a practice invites us to listen to silence as well as noise, to speech as well as what is not said, and to the patterns of sound and silence in all of their many orchestrations."[85] In saying so, she also intimately asks "what can listening do?,"[86] a question that in its multidirectionality might also ask, who can listening do?

Following Oliveros's lead, Steinmetz lays bare the psychodynamic components of deep listening in which every detail of the relational moment says something about someone. In its most critical capacity, deep listening as Oliveros's aesthetic movement promotes, "strives for a heightened consciousness of the world of sound and the sound of the world."[87] Listening is mindful and receptive, yes, but at its best, it is unwaveringly generous, rigorously benevolent, and humane. It is a process of self-analysis and world-discovery in which every detail, even those unseen but always shimmering, vibrates new social scenes. Every article in the scope of sonic relationality contributes to the transformation of the subject, of the world, of multiverses within verses.

As Steinmetz and Vazquez equally share, listening is a two-way street that one actively discharges, a deliberate crossing of feelings that ignores no sound. The apparent nothingness of silence is a robust symphonic score; one must listen deeply to grab the note, one must gather the note to retrieve listening.

Deep listen to the rhythmic contours of the earth.

Sometimes the note and its meaning live in the paralinguistic excesses of language's measurement through expressions of the

sounds that are materially integral to language. Sounds make words different from one another; sense relies on nonsense — infinite nonsensical combinations of sonic difference. It is in these realms where communication recedes and becomes communicability instead; and it is in this communicability that the materialization of the unthinkable and unimaginable is enabled. The study of paralanguage disrupts and resists the power that determines the sovereign. Especially since sounds oscillate and reverberate, one can't follow sound linearly.

The sound might take you out before it moves you back and forward: an escape hatch of dwelling resonances where linear time collapses and listening exceeds its own excess and instrumentality.

Noise and experimental performance artist Erica Gressman understands the intricacies of "sonic relationality"[88] by reminding us of two important matters: first, sounds alone "are very lonely,"[89] they need one another to build composition and to set the scene for the listener; and second, sometimes sound is also light flashing and shimmering, blaring, bodies in movement; sometimes sound happens within the spaces of queer luminosity and synesthetic occurrence, in which "the lonely" is never about sound, but the listener's ability to relate to their senses. It's the non-linear positioning of resonance and listening that produces the composition, as Gressman notes — one filled up with the exuberance of the lonely, too.

On April 1, 2020, a few weeks after the rise of the global viral pandemic within the United States, Gressman performed an experimental performance piece live on the internet entitled COVID-19.[90] For almost twenty-five minutes, the artist works to match the temporality of this viral strand through both sound

and light. In typical fashion, Gressman places quotidian life against the backdrop of urgency through the aesthetic-life-world. She lays on her side, across her sofa, with a bowl of popcorn in front of her on her living room table, and stares into the camera as if she is watching us while we might listen in on her. Wearing a gas mask, pajamas, and socks with holes in them, she models the position of one quarantined: she files her nails, checks her phone and responds to messages, stretches her arms and legs while in resting position and watching the screen, and attempts to eat popcorn against the inflexibility of the mask.

At the same time, flashing lights in blue, green, pink, yellow, and orange mirror the volume and speed of Gressman's noise score as feedback attempts to match the speed of virality, producing sonically and visually the current state of emergency. In the background, wet paint falls from the wall like the spread of the virus – an equally fast and slow drip resembling colors of everyday violent precariousness. Scholar Fiona Ngô has described Gressman's work as an example of "the violence of becoming,"[91] both in quotidian life and within the medium of the avant-garde. Becoming with and against the tension embedded in the violence of a pandemic, Gressman produces a performative scene on screen in which the relational conditions of existence surface their reverberatory urgencies.

Gressman, the Colombian and queer experimental sound/performance artist and design engineer, is not new to producing evocative musical composition from homemade analog electronic instruments that are both sensitive to light and reactive to movement. Her live performance *Wall of Skin*,[92] for example, is a sensorially immersive noise, light, and movement piece with Gressman covered in cybernetic skin. This performance represents an enlivened musical score that literally highlights the

psychological and social effects of skin. Creating live biofeedback performances (blending science and aesthetics) for over ten years, Gressman has transformed her body into various entities – from cyborgs, animals, monsters, and witches to aliens and shamans, and now a quarantined zombie. All of these figures elaborate upon the ideas of embodiment, sound, and technology by coalescing the sentiments of the racialized, colonized, sexualized subject in quotidian life.

A series of vibrations on high alert, Gressman's body of work traces energies that mark a pathway for something other, somewhere else.

Replete with a type of energy that travels outside the known five senses, all sense is a visceral experience beyond empiricism. Pulsating outwardly and inwardly they expose how resonating manifestations are the paradoxes of the ephemeral being materialized. Everything is coming from something and everything is connected by anything in nothingness.

Everything material is not always seen.

Everything unseen is also material.

So how does the body listen in order to disclose the healing capacity of listening?[93] What is the sonic score of genre, style, medium? And how do we listen for the form that inexorably deforms itself in the name of deep relation?

In the forming and deforming 2016 performance *minor matter*,[94] choreographer and dancer Ligia Lewis moves us to deeply listen with her collaborators Jonathan Gonzalez and Hector Thami

Manekehla. Demanding an attention to details, the performance begins in complete darkness as we hear Lewis intone excerpts from Remi Raji's poem "Dreamtalk." Lewis speaks the words, "I would like to turn you inside out, and step into your skin/To be, that sober shadow in the mirror of indifference" whilst reaching out towards "the ultrasound of hidden bleeding . . . images."[95] Beating sounds of rhythmic percussion interweave with the spoken words (that attest to the poet's desire for removing barriers between skin, while reaching out towards ultrasonically bleeding images). Slowly, as the black box theatre space lightens, we hear the segueing lilts of classical baroque music and see three huddled figures at the rear of the stage. Arms open outwards in shifting diagonals and axes; upholding stretched limbs, they rise and lean into each other. Violently, they become entangled across deviating levels and vectors of embodiments and holds.

As the performance progresses, a haunting aria fills the space where the athletics of huddled struggles ensue, a continual sparring between Lewis and Manekehla as Gonzalez detachedly speaks words into a mic: "this can't just be my problem . . . thisssssssssssssssssssss." Speaking of the importance of "discipline, choice, legacy, quality" Gonzalez's speech speeds up and disintegrates into paralinguistic sounds. But then Lewis takes her turn at the mic and the voice we hear emanates into a deep basslike register, where the high and low frequencies of the vocal c(h)ords simultaneously vibrate outwards. "I would prefer not to," "it's not a thing, it's nothing," the eerily doubled voice says.[96]

Music quickens and screeches and changes of light eventually unveil three separate solos tracing repeated steps and twisted bodily abstractions. Gesturing hieroglyphic angles, Lewis, Gonzalez, and Manekehla thump their bodies and clap their hands

in sync, expressing an urgent militancy and emphatic strength through frenzied yet cogent movements. Standing in formation and raising defiant fists together, their faces become distorted. As their fists break down, they link up with each other, leaning back as if pulled. Holding hands as they fall backwards into the darkness, Donna Summer sings "I feel love"[97] and a blue light casts shadows on their constant exertions.

Then from total darkness a single light shines down on Manekehla as he moves to the front of the barely lit stage. He slaps himself on his torso and jerkily dances to turn his back to the audience. In deafening silence as complete darkness descends once again, we hear breath and glimpse the fades of flesh, inaudible talking, and notice barely discernible limbs and shimmering skin. Red lights slowly flood the space as the three performers' outstretched limbs vibrate against a faint mechanical hum. The dancers hold onto each other's extremities, as they lie on the floor.

In horizontal attachment, they connect to each other in grounded slides and linked rolls; their bodies as lines as if on the line.

Through performative modes of embodiment that never settle, Lewis's choreography undoes facile delineations of the dancing body. *minor matter* unthreads the relationship between politics and legibility, for Lewis's desire to tear down the confines of black box theatre walls and representations in dance are inseparable from questions surrounding the representations of the Black Lives Matter Movement. Lewis asks: "Can we institute a practice of togetherness in the minor? Can the black box be host to a Black experience that goes beyond identity politics?"[98] For Lewis, the

matter of Blackness then is no minor matter, but matter as *practice*, as vibrational animation, where light, color, sound, and movement blur in space, and space itself is manifested through undefined configurations. Exploring the color red to materialize "thoughts between love and rage,"[99] Lewis offers a post-apocalyptic space that is both haunting and exultant.

Thinking of sounding bodies and images, *minor matter's* dramaturgy is a resonating operation where text becomes texture and a holding space for sound, color, hue, and cry. These intertwined performances of sound, chromaticity, voice, affect, and gesture, as choreographer and scholar Anh Vo writes, are "the interstices of space, time, poetics where . . . black aesthetics and black politics can fugitively emerge, occupy and concurrently disperse."[100] Assemblages of limbs trace and traverse across intense embodiments because "feelings matter"[101] in the mattering of the charged physicalities of coming together and apart.

In resisting formal representations of black box theatre, identity politics, and the "dancing body," *minor matter* creates an unresolved indeterminate present through interwoven aggregations, where minor matter is all about losing the self to be radically with the other. These experiments for Lewis are bound up with notions of abstraction and nothingness and how nothingness is always-already a kind of matter. Flesh vibrates across choreography, not just legible bodies. And Lewis importantly describes this particular work as the musical genre "noise."[102]

Towards the conclusion of *minor matter*, red lasers cut through the black box in slanted axes as the three dancers recline in inclines. Their bodily axes deviate into a mass of rolling flesh as they become knotted. From a horizontal enmeshment, the three dancers shift

into an intertwined verticality, and we hear a moaning inseparable from singing. The space is lit again and frenzied dancing, falls, and throwdowns ensue. Progressively, they engage in a strenuous exercise of awkward and precarious balancing acts, attempting to hold each other up; "hold it!" one of the dancers shouts, but they keep on falling and falling again and again. Sometimes they use the side walls of the black box so as to be able to hew onto each other, their hewing bodies keep on trying, as one says, "I got you." Lewis screams "Blaaaaaacccccck!" and the performance ends in pitch darkness.[103]

Mobilizing different layers of Blackness, *minor matter* includes the tensions between resonance and dissonance, holding, touching, and collapsing across a choreography of noise. In its explicit desire to exhaust the limits of singular and representational form and materiality, Lewis asks: "what does the dancing body sound like as opposed to look like?"[104]

What are the frequencies of the dancing body, and how do these frequencies materialize and stimulate other bodies through the mattering of feelings?

For sociologist Hartmut Rosa, social "resonance comes into being only if and when, through the vibration of one body, the frequency of another body is stimulated"[105] and proposes that these vibrations are deeply transformational world relations. At the same time, for the author, resonance can never be instrumentalized and is always ambivalent; it is a differentiated response rather than a repeated echo across the pluralization of singularities. At the core of Rosa's work is the idea that resonance may instigate the unraveling of social alienation and capitalist acceleration since desires vibrate in and across all experiences of the given

world-system. As unpredictable, strained and fragile as Lewis's balancing acts, social resonance, for Rosa, is experienced through a rapport that can never be forced.

These desires tremulously transverse quotidian life-worlds and in their manifold dimensions lean toward a harbored promise of the not-yet. A way out of the capitalist colonization of our marketized everyday, and the everyday matter of violence, as both Gressman and Lewis flesh out, is to tap into an unacknowledged social resonance that rings of noise. Such resonance can never be pinned down philosophically, as it is an "immediate experiential reality"[106] fostering (dis)harmonious singular and social dispositions.

If Rosa's study provides a critical theory of the "resonance of resonance,"[107] then in disrupting the relationship between legibility and politics, both Gressman and Lewis show how marginalized populations are framed within specific pre-formed contexts and imbued with pre-formed content determined by scientific norms and their sociological axes. Rosa's resonance-focused method of sociology traces dimensions of reverberation by way of a diagrammatics of resonant "axes" and how these "axes of resonance" construct different "world-relations."[108]

Yet, Gressman's and Lewis's "noise" complicate Rosa's delineation of axes by exposing how making noise is also about remaking flesh, through engaging non-representational and non-linear frequencies. Their respective performance practices reveal how, although operational, the force of resonance across aesthetic-life-worlds insistently escapes administered imperatives.

So let us repeat the question:

> how do we listen for the form that deforms itself
> in the name of deep noise?

From axes of resonance to axes of noise, Gressman and Lewis rethink the sounds of the moving body as opposed to its situated visuality. Challenging sensual orders to land us in the realm of immersive embodiment, these artists know that the resonance of resonance is a politics of solidarity held intimately in the sensorium.

The senses, while matter, are hardly only minor. The intergalactic dark matter of Sun Ra's Arkestra creates a dynamic life-world by embodying his and their own sensoriums. The Arkestra, who have been playing together for almost 80 years, still follow their misfit band leader from Saturn, Sun Ra, to sonically and visually travel in interstellar dust.[109] Deeply listening to the details tremoring in the revolutionary orchestrations of the Arkestra, we hear resonant shudders across practices, galaxies, and axes, not just respiring in the form, but living in continuous formlessness. From nuclear war and space travel, the Arkestra's songs, compositional intervals, and improvisational jazz and noise travel to the unknown and impossible because it is the "unknown you need to know in order to survive."[110]

These travels to unknown spaces entail risk, chance, collaboration, improvisation, and trust, as the aesthetic-life-worlds of Gressman, Lewis, and Ra disclose. Listening to the details of the unknown, our unknown is antithetical to Empire's anti-galactic fascism. For within all forms of planetary organizing there are orchestrations and choreographies moved by the quivering rhythms of vibrational solidarity and ethics.

As the Arkestra teaches, these orchestrations must be ones of lanquidity, love, and open doors to the cosmos. These communal echoes rub up against each other, performing their coordinate and discrepant sonority because as Ra knows, with all love to spaces of other places, comes the violence of Earth. In this violent soundscape, Ra sings that "radiation, mutation, hydrogen bombs, atomic bombs," are a "motherfucker" waiting to blast "yo ass" in the name of nuclear war.[111]

Thus, in moving into the quotidian orchestra of things, entities, assemblages, and ecologies against all war, our anticolonial is already anticapital; the contexts and contents that separate the two cannot be used as principles to understand the mythic qualities of our formless formation.

For like Ra, we, too, believe that "we hold this myth to be potential/ Not self-evident but equational/Another Dimension Of another kind of Living Life."[112]

Vibrated differently across interstitial shareability, resonances are never a singular experience. To transmit signals from the formation of other refrains is the resonance of resonance.

In the constant violence of becoming and exertions that seek to exhaust form, they open doorways to the senses, dropping us into minor realms of matter and astro-loveology.

To vibrate, to touch, not like a tap but a grasp, is to deeply listen in order to connect with another living life of another kind and place, to know when to hold back, to retain the refrain, or to decelerate frequency to change the band widths.

Feel vibrations under skin.

Play the track.

Listen to the
sound.

ENSEMBLE

I f the ensemble is a portal and passage, then resonance is the necessary way through, a getting through to get on the way. And the way through is a tinkle, a stroke, a push, an out-of-breathness. It's both a listen and a response: a place where there is no sound without the tempering of the ear. This getting through is often off-kilter, or an ongoing start and stop in which the show is just another rehearsal. Without practice, there is no ensemble.

"Wait for me," a member of the ensemble says, and then another, then another, then another, because the leader of the ruckus is never absolutely clear. The underpull and the flight all happen at the same time, for swaying towards others is to want to be singled out, knowing that the solo is no solo without company. The rhythmic section makes a segment, inviting an opening that's cut by key changes breaking through rhythm's frames.

Sometimes the only way up is down, where down is up and simultaneously a type of sideways.

But to move sideways one needs skill to know when to lean on something, someone. This leaning and splitting ensemble is an aggregation in composition, an accumulative shedding, a making do, a getting through, a collective travelling to another place that

is also this place and that space. It's a roving together with a one way ticket, for there is no going back to what the ensemble once was because the ensemble loses and gains itself at the same time.

The ensemble is the ebb and flow of encounter, a concession to share desire while following a sound, a rhyming, a constant eruption in time, an appearance and disappearance in the name of imagination.

Collaboration is a verbing born out of "the unfinished genesis of the imagination."[113] Like listening, imagination is collaborative, a type of relationality that is animated by actively sharing labor. For one is not the single author of aesthetics and culture, but shares the process. Sometimes, in the deepest of connections, art writes the writer. Ensnared in tension and harmony, objects, ideas, and subjects activate and generate imaginative scenes. As resonance predicts, most conversations, while not yet documented, were always-already informally and innovatively entangled and endured.

By privileging imagination, creativity, curiosities of care over identity, resonance guides forward an ideology and consciousness that necessitates solidarity. *Moved by the Motion* is but one example of the capability of collaboration. An ensemble of fluctuating members, created by and including artists such as filmmaker Wu Tsang, boychild, Asmara Maroof, Josh Johnson, and many others, Moved by the Motion is made up of DJs, musicians, dancers, artists, poets, writers. This ensemble is a formless formation where members come and go and return constantly. In one of their live performances, *Sudden Rise*,[114] Tsang recites a poem[115] written with both Fred Moten and boychild. While written together, the poem harbors another voice as it is inspired by a line in one of W.E.B. Du Bois's essays[116] — that line becoming the title of the poem.

As Tsang incantates the poem, boychild and Johnson dance to the reading as well as to Maroof's electronic sounds and Patrick Belaga's cello. Without a script and in an improvised manner, the music responds to the interlaced projected images and movements of the dancers. The dancers' bodies are captured by images in real time on huge screens behind them, enabling an eerie doubling of their dance; a choreography composed of countless falls from a raised platform and mirrored in different temporal registers.

Sudden Rise echoes Tsang's films *We hold where study*[117] and *One emerging from a point of view*[118] in which the artist uses the filmic techniques of overlapping, blurring, and splicing images to join two horizontal screens. Expressed in the inseparability of difference through stills protruding into one another, the channels conjoin in the middle. Fluctuating and folding in formless formation, the borderless, cinematic panoramas bleed and melt into each other to meet between spaces and times that are at once singular and also adhered through the assembly of images. Cinematically stunning and politically convicted, Tsang's blurs and fades into other worlds are the studious affections of intricate embroilment.

Blurring and fading are aesthetic strategies as much as they are political accomplishments. Tsang's courageous ensemble reflects Édouard Glissant's archipelagic thinking to promote a shared unknowability that breaks through the dialectical limits of opacity and transparency. Enacting a visual and sonic *poetics of relation,*[119] Tsang encapsulates the ensemble of resonance across space and time by way of non-linear associative principles. Like Glissant calling the reader to listen to the echoes (the feedback) and chaos spiraling within what he calls *la totalité-monde,*[120] Tsang evades the ambush of transparency by embracing opacity. For both, opacity is an analytic for reading, thinking, creating, performing, and also

a practice for being with others — one that privileges traversing operation over reductive delineation.

Striving across resonant frequencies, a praxis of accompaniment promotes the recording of archipelagic aesthetic-life-worlds in which the imaginative openings of opacity ensure transformative modes of historical overlap between entities. Multiversal relation-alities attempt to rescore existence by what *gives-on-and-with*, not by the representational clarity and absolutism that often violently consume all life energies.

Tsang tracks down the violence of representation by following the ways in which the camera operates. "There is no non-violent way to look at somebody"[121] argues Tsang, a proposition that is also the title of a 2019 exhibition that draws from a sentence in the text "Sudden Rise at a Given Tune."[122] Revealing how theoretical and aesthetic forms advance into other formations, Tsang suggests that the double negative in the title highlights the layers of intention within filmmaking. These intentions are seen across points of critical understanding: 1) how the recording of documentation is always pre-intentional and can be thought as conjoined to histories of social movement as documented; 2) how documentarian choices are imbued with the filmmaker's desire to not be violent to their subjects, and in consequence, do justice to their stories; 3) how giving voice to the voiceless often leads to sinister operations within documentary filmmaking as a genre. The violence, for Tsang, is situated within the intention, desire, and execution, none removed for the trap of transparency.

The ensemble responds to this violence through a turbulent and unpredictable aesthetic assault on the capturing frame itself. Aware that the aesthetic life world is interlaced with the violence of the

apprehending image as well as the violence of everyday life, Tsang denies their separation. But what does one do when the camera looks back, initiating a visual hail that reorganizes documentation itself? For Tsang, the answer lies in fully admitting that violence overshadows the system of seeing.

Inherent to the act of viewing and recording, then, is the negotiation with representation, for there is a necessary cut to touch, a necessary conflict within entanglement and relationality, like the elemental forms engendered from the camera. From the recurrent still, the shot-reverse-shot, the splice, close-up, zoom out, or the show and tell of a manipulative lens, the camera exposes how there is no non-violent way to hold a camera, to look, to fundamentally see one another. The ratification to violence lives in the tangled particulars of the ensemble.

And Tsang's ensembles are immersed in the intricate details of social movements across entangled performances. This is also to share that the aesthetics of the ensembles of rebellion are never removed from the aesthetic practices used by the state to mobilize against political uprising. Although capitalist economies and police apparati attempt to erase the ways we are conjoined, planetary protests seek to transcend the capitalist nation-state's necropolitical social structure funded in the name of anti-Blackness, anti-queerness, anti-subalternness that leave the most vulnerable for dead. In response to such violence, Tsang offers the blurring image as an act of counterinsurgency; still upon still, Tsang discloses the right to be complex, opaque, to be interarticulated in an aesthetic strategy of collaboration.

If collaboration is methodological, then the aesthetics of protest and rebellion must also disclose the compositional frameworks

and organizing principles of social resistance. Such a claim also unearths how regional rebellions comprise an ensemble of planetary protests via the urgency of resonance.

Resonating frequencies of rebellion across the globe are performed in how planetary protestors mobilize their aesthetic choreo-discursive-politics, seen in how they walk, run, lie down, and sit, along with their linguistic advances in signs and chants, all collectively reverberating demands, dreams, and declarations. Take for instance the choreo-politics performed in Santiago, Chile at the end of 2019 against rampant femicide and sexual assault in an anti-state collaborative dance and song mobilized by militant feminist organizers. Since its inception, this choreographic insurgency has been danced and chanted by women across the globe, communicating a planetary solidarity that exceeds governmental preeminence. Chile's "Un Violador En Tu Camino"[123] is just one aesthetic example of the shared planetary struggle against the possession of life.

Or take the contemporary events against anti-Black fascist policing in the USA that are countering the state's mandate by a collective rebellion across a staggering number of cities and continents. The ongoing US uprisings of Summer 2020 advance the idea that the occupation of land and life is never defensible. As such, the ensemble emerges throughout the motley colors of clothing, the white masks of milk and antacids used against tear gas, the bandanas and balaclavas that shield and mark their underground intermingling cultures. Countering occupations of all accords, from the human body to the ecological, are heard in the resonating urgencies echoing across the plenum. As social media captures the violence of looking at somebody, rebellion maintains and transcends the shot.

For this time, the ensemble is televised.
For this time, the revolution is on screen.

The desire to respire in solidarity has travelled far and wide. For an unprecedented example can be found with Black indigenous resistors on the other side of the globe shuddering in resonance with the US rebellions as they, too, fight from within their own experience of colonialism and genocide. The West Papuans have sounded out their solidarity, expressing how they stand together with those fighting against anti-Blackness in the USA.[124] Their own struggle against the Indonesian military that kills them in the service of American and Canadian gold mines uncovers the endless pursuits of colonialism that they wear singularly but feel planetarily. Their battle in solidarity, only another example of a new world social order formlessly forming against occupation and oppression, vibrates similar yet different contexts in which anti-anti-Black genocide is at the apex of all revolution and liberatory domain.

Unearthing the swerving poetics of protest through clamorous details, the revolution manifests in the aesthetic-life-worlds of the part and the crowd.[125]

And neither the part nor crowd, like the aesthetic
and the political, serve in metaphor.

On the flip side of these uprisings, the planet's police also have their aesthetic tactics in the form of robocop gear, the design of hold and attack, the helmets, gas and rubber bullets, wailing cars, and raining batons. The logic of the police's ensemble is a militarized one, an order that protects a certain sociality that is defined and motivated by property and profit. All logistics for social organizing

commence with militarization, for "the military-industrial complex stabilizes capitalist activity, absorbing its excesses by producing armaments, surveillance tactics, and ever-diversifying uses of security technology."[126] Created from hierarchical efficiency and observation, to think further with Foucault's birth of the prison-industrial complex, militarized existences rely on structures of surveillance, obedience, discipline – all working in favor of the marketization of the state; for to resist those designs used to mold "docile bodies"[127] is to commit to lawlessness itself.

Every component of social order is regulated by the smallest detail, technicality, scheduling, and specialty. Observed across institutional parameters, from schools to churches to prisons and orchestras, in attire and speech, to movement and silence, these are the "means of correct training"[128] that Foucault imagines as the dissolution of a complicated sense of being.

Enforced by governing institutions, the aesthetic follows a schedule as well, often marketized and commercialized, mobilized as propaganda; a mainstream cultural perception of leisure; an after-joy occurring once the ideological program has been completed. But let us not forget that even when neoliberalism perpetuates the violence of the aesthetic, the aesthetic-life-world shows us how to live off beat and to breathe together against traditional constructions of space and time.

So how might we critically communicate the seriousness of the aesthetic within the crisis of representation? How might we score the interarticulation between the violence of representation and the burden of liveness? How does the aesthetic-life-world lead us into new constructions of being alive/live, unfamiliar modes for remodeling existence?

Like the violence of the governing frame, the burden of liveness is never removed from the institutionalization of the aesthetic. For as Tsang critically expresses, the violence of representation both defines and directs the living by how one comes to understand the process of viewing. Often led by a transparent notion of the senses, both the crisis of representation and the burden of liveness withdraw from opacity as a strategic mechanism for social relations. In theorizing this burden, Muñoz claims that there is a constant "need for a minoritarian subject to 'be live' for the purpose of entertaining elites."[129] That is to say that the transparency of the subject produces its circulating value and in enacting modes of difference that appeal to elites, the minor voice, in all its different tenors, is subdued for the major. Called upon to perform in the *now* with no recourse to the past, minoritarian subjects are also denied the future. With no future and no regard for the subject as a historical one, the crisis of representation, across bodies and aesthetics, delimits the conditions of possibility for collaboration. In fact, the burden of liveness becomes the very crisis of representation all uprisings seek to abolish.

By insisting on the histories and futures of those uncounted and unconsidered, Patricia Nguyen's ensemblic practices reject such burdens of liveness and slick categories of representation. Working against the separation of aesthetics and politics, Nguyen sees their connection as inherently symbiotic as she travels across diverse cultural spaces and encounters with subjects who must negotiate everyday histories of violence and trauma.

In an interview regarding survivors of sex trafficking on the borders of Vietnam with China, Nguyen addresses how she collaborated with groups of women from ethnic minorities and indigenous backgrounds, across linguistic and educational barriers in order

to create a large mural that encapsulates their singular stories into a collective voice.[130] For Nguyen, it is precisely the aesthetic practice of producing a common project that helps surpass the divisions and differences between disparate peoples.

In a later work where she collaborated with survivors of police torture in Chicago, Nguyen, along with collaborator and co-founder of their Axis Lab, John Lee, designed the *Chicago Torture Justice Memorial Project* to privilege survivors' stories. Most important for the survivors was the visible inclusion of their names and manifestos within the site. Nguyen and Lee envisioned a "monumental anti-monument"[131] functioning as an archive for the struggle for reparations, while simultaneously offering a community space for organizers.

Nguyen describes her approach to community engagement as "rooted in performance studies, women of color feminist theory, and Black radical thought," along with her staunch belief "in the power of cultural production to shape our collective futures" across "working class communities of color to resilient transnational struggles for liberation."[132] Through performance and visual art, movement analysis, and theatre, these connections conjoin human sentiment and heal trauma through the fortitude of the aesthetic. Nguyen notes that her practice is grounded in "the belief that political struggle is a collective durational performance carried forth across generations."[133] In its multitude, this collective durational performance mobilizes the aesthetic to make visible an ensemble of stories, for all of Nguyen's collaborations with others are, at heart, acts in catharsis.

In redressing state violence through storytelling, Nguyen reorders historical precedent and deliberately asks, "what is our role as

cultural producers in the face of continued war, police brutality, mass incarceration, and poverty in our nation's history?"[134] Unable to disconnect activism, art, and academia, Nguyen brings to light their entangled solidarity in all of her projects and performances.

Entangled solidarities extend beyond human relations for Nguyen. Critically combining different materials and elements to link the human with the earth, her performances precipitate new ecological resonances. In a work that underscores what she terms the "materialities of confinement,"[135] Nguyen interlaces choreography, lighting, concrete flooring, and a mylar blanket in her performance *Echoes*.[136] Nguyen covers her body with the mylar blanket and vigorously rolls on the floor, producing a moving terrain of silver and colored lights that express how all material is intertwined and experienced simultaneously by those in confinement. In each turn left to right, she depicts the duress of South East Asian refugeeism as well as a seascape and landscape that reflects the refugee body in spatial suspension with all elements of the world. The aesthetic and performative particularities of this piece, as captured through video, impress upon the viewer the full sensorial undertakings of those ensnared by the state. As Nguyen sways from side to side, her face extrapolated from the scene, the viewer feels the tight enclosure that collectively impedes the dispossessed from escaping their everyday imprisonment.

Her work is an ensemble across elemental solidarities, recalibrating the potential of being and breathing together, of holding on against the afflictions of representation and liveness through ecological solidarity.

Ensemblic living is a practice of rigorous connectivity across aesthetic-life-worlds. It is the active refusal to live apart, while

staying a part, being a part, a particle of the void. It is also about declining to be the exception because exceptionalism is always an anti-anticolonial project. This double negative, as Tsang cautions, is to also acknowledge that to frame something is to cut something out. For the cut is more than erasure: it is an entry point into something else and a simultaneous escape from everything other, a kind of breakout caught not only on screen, but lived in everyday life.

As these aesthetic-life-worlds summon, to tear a cut into the world is to intimately remake it, not through the singularity of a sense, but through the intricacies of the sensorium. For the senses are never removed from the social scenes that implore them, instead they work in tandem, in ensemble. That is to say that the aesthetic-life-world is a sensorial and active affective mapping that underlines how existence happens through an "ensemble of the senses."[137] For it is impossible, as Moten argues, to create a distinction between the "ensemble of the sense" and the "ensemble of the social."[138] For Moten contends that "there's a sociality of the senses — which is a formulation Marx makes, *when the senses become theoreticians in their practice*"[139] Emphasizing the inextricable nature between the multi-sensorial and the multi-social, Moten, in turning to Marx, understands that when we critically attend to the senses as theoreticians we go "against the grain of a whole lot of commonplace formulations people make about aesthetic experience, and about the place of aesthetic experience in the formation of the subject."[140] For us, the senses harbor the potentiality of new social orders as the ensemble divulges the serious intentions of the aesthetic. Never removed from the conditions of the social and the subject, the aesthetic-life-world regenerates global breath.

These ensembles are inseparable from world study and integral to the aesthetic-life-world, where the social, psychic, and material bind in sentiment and action. Or as Tsang, Nguyen, and countless other artists/activists/scholars show, to understand the senses as the social, as an exercise of the ensemble, is to counter the limits of seeing, knowing, and doing. But it is also to bypass the boundaries of representation and liveness, to push past their crises and violence in order to instantiate embroiled formless formations.

The ensemble is always the flux and influx of encounter, the greeting of spirits and the tenacious agreement to hunger together while chasing a sound, a sight, a timing, a rhyming, an animated burst, a flight into an appearance and disappearance.

To orchestrate is to mobilize divergent coordinates, the arrangement of the bassline undaunted by the melody; the major chord and the minor key, registers varied and altered in dynamic pull. From the heavy weight of a deep beat to the dark expression of abysmal feeling, the changing lead sheet deranges the arrangement.

Assembling bodies, feelings, and fists, orchestration is where the swarm and ensemble multiply the score; and their discrepant union is visual, haptic, a kinesthetic composition of tuned and toned instruments – all notes, big and small, tweaking key changes against the scrim of an impending hiss. From the trumpet to the trombone, sound references the body, just like the enduring body instills and changes the measures of composition.

Think of Louis Armstrong blowing out a new social order to lead the band: in his breath, a facial twitch, the horn player knows when to blast scatting vibrations. Listen for the trumpeter Satchmo blaring in sonic elegance to then hail in the band because the solo has ended: this is an exegesis for life, where sounds let bodies stand in. There's *no solo without company,* and there's no record playing without the player; corporealities in exquisite collaboration moved by the practice of practicing itself.

Armstrong's unique diaphragmatic compositions and improvisations have irrevocably altered the planetary soundscape. His epic and enduring transformation of the trumpet's sonorities speaks to how instruments have always been deconstructed by artists and their orchestrations to shatter the militarization and "civilizing" of musical form. Armstrong's aesthetic interventions include the alterations of music, sound, sense, voice; he produced countless collages, correspondences, two autobiographies. A prolific archivist, he called his type writing "gappings" mobilizing multiple registers through bizarre uses of punctuation, underlining, and ellipses of varying length. From the trumpet to the typewriter, Armstrong seemingly "revel[ed] in appropriating the technology of rationalization,"[141] where his writing can be read as the usurping of the "rational technology of the interval ("gappings" – in the sense that the typewriter structures and spatializes an access to language) …."[142] Armstrong's practices of improvisational pluralism across multi-media collapse the divisions between high and low culture, class structures, and formal registers and, in their criss-crossings, traverse the gaps between transnational culture domains.

In breaking down the scoring system to outrun Empire's violence, Armstrong is just one example in a string of artists and insurgent creators who appropriate colonial instrumentation and rational technologies through performative modes of alterity. Like the orchestration of new sounds, these anticolonial practices occur within a shattered continuum, and it is the listener's (reader's) job to decipher the sequencing order of content and context in the gappings of reanimated form.

The social ordering of Westernized human life historically works through the appropriative structuring of logistical militarization, and such an operation is an orchestrated assembly working in

capitalist service and servitude. The proletarian struggle against such orchestrations is determined by the colonial one in Aimé Césaire's poetics of revolt. He refers to "the colonial problem" as the dilemma that essentially creates the equation "colonialism=thingification."[143] In noticing the "extraordinary *possibilities* wiped out"[144] for the world by colonial violence, Césaire points to the connections between colonialism and "proletarianization" – the latter works to produce subjects into "civilized" laborers and commodities. Simultaneously anticapitalist and anticolonialist in its diagnosis of Western civilization's eternal strickenness, Césaire's treatise confronts the disease that is the colonial enterprise.

The liberating power of anticolonial revolt, as Césaire sees it, happens through orchestrations that do not conform to "narrow particularism."[145] Working between the dialectic of a particular-universal, Césaire divulges that he does not "intend either to become lost in a disembodied universalism" for he has a "different idea of a universal."[146] Césaire's universal is "rich with all that is particular, rich with all the particulars there are, the deepening of each particular, the coexistence of them all."[147] Poetically raging against European civilization's universal profiteering propelled by racial hierarchies, Césaire announces how in its abhorrence to the coexistence of deep particulars, fascism is inherent to colonial atrocities.

If the "civilizing" conventions of colonizing Western orchestrations are ritualized following a standard hierarchical order of use instructions, masters, lead instruments, Césaire's and Armstrong's orchestrations are ones that continue a "fleshing out" of coexisting particulars whilst challenging the material conditions of commodification and alienated labor. In thinking with Césaire and Armstrong, what would it mean to advocate for orchestrated

aesthetic-life-worlds that decline the monolithic labels for social order, and that in their rejection of thingification galvanize militant, poetic, and sonic resistance?

To orchestrate is to score the rearrangement, planning with the elements of the world to produce a desired effect that will land us in *the future of the future* still imagined.

The aesthetic-life-worlds we imagine resonate with worldly compositions for abolition and liberation. Take for instance the Zapatista Army of National Liberation in Chiapas, Mexico who call for "a world in which many worlds fit."[148] Engaging in what Manolo Callahan calls "convivial research,"[149] the habits of assembly at the heart of Zapatismo move beyond mere critique in order to work out collective tools for communal safety, conviviality, and sustenance. Zapatismo requires a move away from simple solidarity to direct action in the face of global paramilitarism. These collective obligations are ones that conspire (plan and breathe) together in order to organize against lethal states of ongoing war.

The Zapatistas's militant operations are defined by all-masked orchestrations in which singular identities and leadership roles are pushed aside for ideality and direct action, or as they declare: "para todos todo, para nosotros nada"[150] (everything for everyone; nothing for us). The slogan "para todos todo, para nosotros nada" celebrates the coexistence of all particulars, whilst abolishing the subjective voice that speaks in the name of a separatist "us." This slogan "runs so counter to anything any of *us* — the resource-hungry individuals of the so-called First World — would ever think of demanding."[151] Theirs is a crucial reminder to the necessary planetary organizing against climate change today: "no one ever rioted for austerity. Yet, without feeling cheated, we need to build our capacity to live by

another old saying: enough is better than a feast."[152] In this regard, the Zapatistas's demands for regional autonomy and the general strike work against corporate globalization: theirs is an anticapitalist anticolonial movement that counters our current no-future in the name of an ecologically sound world formed by many worlds.

To insist on terms like anticolonial and anticapital is to look for exits from Western temporal and spatial containment. It is to refuse modernity's reliance on linear time and chronology as the dominant frameworks to perpetuate the illusion of global development and historical progress. It is to resist the epistemological, ontological, and genealogical labels that compartmentalize the colonial enterprise into postcolonial, decolonial, neocolonial, settler-colonial, developed First world, developing Third worlds. And it is to disentangle the spatial politics embedded in each prefix, so that geographical and discursive contexts (for example, postcolonial: India, decolonial: Latin America, settler-colonial: US and Australia) do not overdetermine a synchronous anticolonial project in which multi-directional resonance scrambles traditional temporal and spatial orchestrations.

To orchestrate solidarity and direct action is to constantly place pressure on these terms, underlining how the prefix often marks a temporal misfire in its spatial containment. If the prefix is meant to be a temporal marker, but really performs a spatial one, what's the plural project of anticolonialism across borderless regions? To be clear, formless formational organizing resists essentializing or conflating anticapitalist struggles. Orchestrations informed by resonance contain all the myriad cultural logics, internal contradictions, and the gaps between them, that sustain particular histories and experiences of colonialism and empire. However, as the representations internal to the capitalist logic of class struc-

tures are always-already racialized, gendered, and sexualized, then anticolonial, anticapitalist formations consist of praxes seeking to abolish systemic capitalist social and economic relations in an orchestrated coalition of reconstruction across discrepant imbrications of materiality.

Colonial structures cultivate form, defining exception, contextual property, value, permission, and the refusal to "consent not to be a single being."[153] An anti capitalist orchestration is the antithesis of exceptionalism because orchestrated exceptionalism has always been the first tenet of fascism, the first motivating momentum of the singular. In locating radical connections and deliberately enacting these types of discrepant arrangements, resonance is our guiding method. What may appear as jumps in logic, or clumsy object relations, is rather an intentional act of both ethos and epistemology. In other words, to subvert the lines separating our fields of anticolonial and anticapitalist study is to orchestrate a form of monster migrations.

Until the conditions of possibility for a future encourage multiversal existences, the future will always be marred by the deadly and intertwined politics of colonialism and capitalism. Contrary to the idea that the anticolonial and decolonial are different sides of the same coin, they harbor unique ideological properties neither of which are to be used as metaphors. "Because settler colonialism is built upon an entangled triad structure of settler-native-slave, the decolonial desires of white, non-white, immigrant, postcolonial, and oppressed people, can similarly be entangled in resettlement, reoccupation, and re-inhabitation that actually further settler colonialism."[154] Or, the contest to survive in competitive capital is what furthers "settler colonialism." The metaphorization of decolonization makes possible a set of evasions, or "settler moves

to innocence" that problematically attempt to "reconcile settler guilt and complicity, and rescue settler futurity."[155] This is also to say that colonialism's preservation is dependent on the workings of a settled identity as property of capital itself.

The sounds of the oppressive and colonizing apparati of form are everywhere: identity, time, fields, methods, disciplines, interactions, genres, histories, and even movements. Often indexed visually, form relies on facticity to define, separate, and catalogue; however, a resonating sensorium undoes sight for the benefit of the plenum. If the phylum is the ordering of all classes made up of infinitely materialized particulars within the plenum, then the plenum of the pineal eye of Western rationality is incapable of ever sensing how resonance senses.

Writing during the 2020 pandemic, Indigenous Action warns in "Rethinking the Apocalypse: An Indigenous Anti-Futurist Manifesto" that colonialism "has infected all aspects of our lives, which is responsible for the annihilation of entire species, the toxification of oceans, air and earth, the clear-cutting and burning of whole forests, mass incarceration, the technological possibility of world ending warfare, and raising the temperatures on a global scale, this is the deadly politics of capitalism, it's pandemic."[156] Capitalism is the ultimate deadly disease that increases force through constant acts of violence against Indigeneity, all life. It rests on the death of the Indigenous and the destruction of entire species by engineering time and propagating annihilation; "it is apocalypse, actualized. And with the only certainty being a deathly end, colonialism is a plague."[157] If colonialism is a plague and capitalism the pandemic, then their embroiled infections are the organizing principles that attempt to decimate Indigenous life, one that refuses to disappear in the name of profit.[158]

Indigenous Action are accurate in attesting to the non-future of the most vulnerable. The swarming viral pandemic of the 2020s affirms the mortal/immortal speed of catastrophe. While one does not have the capacity to outrun the veracity of the strain, our vulgar conception of human exceptionalism presumes to monitor the speed of tomorrow. Viruses, like pollution, work rhizomatically and galactically; they do not abide by the human rules of time and spatial order and yet they unveil the class disparities of wealth and oppression under luxury consumerism and racial capitalism. Although it appears that the virus' only border is its symptoms, the dormant and asymptomatic power of contagion disputes this logic.

By seeing ancestral insight as outdated, living in the past of premodern ideas, the colonizer privileges corporate value over a multiversal future. But Indigenous Action smash this fallacy by expressing that "they (the ancestors) understood that the apocalyptic only exists in absolutes. Our ancestors dreamt against the end of the world."[159] In other words, ancestral insight and knowledge already predicted contemporary life and its movements forward in time, seeing the future before the epistemological elites plundered culture, Indigenous life, and land into proprietary sellable form.

This means that our enemies are often members of the same orchestra. Not only as the colonial police, but those that seek a seat at the table, a cut of the profit, or our death at the expense of their exceptional walking careers; all of this conducted in the face of their anti-relational no-future theory that celebrates a perceived exceptionality propelled by global mediocrity.

So, let us not forget that form is a colonial project. It is advanced by capitalist and colonial structures unable to escape their own indexical present. This present, dismally, annihilates the presences

of future life by deliberately bypassing past injustices and the constant furthering of colonialism and war.

And yet, all is not lost: new orchestrations across transnational, identitarian, and regional pluralisms constantly emerge. See how the Arab Spring of 2011 directly inspired and propelled the Indignado and Occupy movements that followed it, and how surprising practices of mutual aid are ongoingly orchestrated. Such as in 2011 when Tahrir Square protestors in Cairo ordered pizzas online for striking workers occupying the state capitol of Wisconsin. Or when in 2015 Palestinians advised Black Lives Matter organizers in Ferguson, St. Louis as to how to handle tear gas, and then a year later we witnessed US military veterans fighting side by side with Indigenous warriors at Standing Rock.

Today, the 2020 US rebellions have discharged profound reverberations of rage across the world and unexpected forms of solidarity such as the K-Pop stans' sabotaging of racist hashtags, rallies, and US police radio signals. These global aesthetic socialities of protest are made possible by "the organizing networks of algorithmic technologies of the common" that express "the possibility of alternative cartographies of the political."[160] Social movements in ongoing processes of transformation disrupt mass media's attempts to compartmentalize emergent configurations of defiance and heterogeneity. By way of embodied practices that shift boundaries across struggles against the proletarianizations of colonization, a common recognition for the necessity of organizing shared dissent arises.

These orchestrations of solidarity across experimental improvisations of form require the obliteration of conventional and mainstream "maps and mappings" in order to "try to imagine something

else."[161] An aesthetics of cognitive mapping[162] that recognizes gaps and gappings, at the same time as it resists subjective dislocation, orchestrates radical cartographies of the present.

Our formless formation consists of traversing acts of mutual aid and direct actions that surpass the metaphor in place of orchestrated praxes.

New cognitive mappings and orchestrations exceed nation-states' and diasporas' spatial and temporal conditions. These aesthetic-life-worlds tracing alternative cartographies are queer in their crossings, gaps, and off-centering tilts.

Creating an orchestrated Caribbean sensoria that models transnational solidarity and diasporic unruliness are the monster migrations of the six-foot tall Dominican and queer novelist, multi-media artist, songwriter-singer, model, musician, and trombonist Rita Indiana.[163] "Known as *la montra* (the female monster),"[164] the monster migrations of her band Rita Indiana y Los Misterios blur sound, image, and embodiment through the art of musical and linguistic fusion. While demonstrating the expansion of chord progression and sonic notation, her fusionist practices also parallel the migratory transitions of the aesthetic cognitive mappings of diaspora. These monster migrations are found in tempo changes and new rhythms that accentuate the galloping beats of merengue, but also the rushes of emergency that move within notes and across bodies of land and water.

In the video for the song "Da Pa Lo Do,"[165] for example, Indiana attends to the particular nationalist strains between Haitians and Dominicans by overlapping musical, historical, and visual aesthetic forms associated with diverse cultural scenes embroiled

in Caribbean history.[166] Indiana positions migratory crossings
between Haiti and the Dominican Republic through the ascension
of revolution, race, religion, and the overlays of musical compo-
sition by performing as a queer force conjoining nations amidst
a long history of colonial violence.

But it is in the video for the song "La Hora de Volve (The Time to
Return)"[167] that the avant-garde monster dynamically takes on the
other-worldly components of migratory passings. In this video,
dancers fly on vinyl records/flying saucers in an apocalyptic land-
scape in outer space as the artist sings of and into a dreamscape
of another planet for the possible return home. Yet where is home
when the snowy streets of New York City seep into tropical veins
and numb labor? How is the return home not another term for
departure when "your time is up, papi?"[168] As vinyl records and
alien creatures fly out of her singing mouth, against a constantly
repeated choreography of shoulder shrugs and some merengue
four-beat-feet keep a syncopated pulse, Indiana sings: "Take a
plane dammit!/An upside down raft./ You don't see?/ It's time
to come back!"[169]

As her call to return home progresses, the video itself returns to
the MTV-era DIY aesthetics of the late 1980s, with its ad hoc
collaging and bright garish colors amidst all black costuming. As
she sings, "Sometimes people want to move/They wanna go and
see/How is the other bembe/You left, you got hit, you came and
you made"[170] two very tall male backup dancers multiply into an
infectious rhythmic line of many dancers, queerly migrating in their
joyously convivial moves against straight times and straight scenes.
Indiana brings to the fore cultural remixes that land migration in
queer science fictions and queer multiverses.

By listening to the politics of race, sexuality, and gender in her intergalactic songs and music videos, one can hear "her multifaceted style" mixing "merengue with elements of hip hop, techno and Afro-Caribbean sound" including rock and Dominican dialects.[171] Indiana's aesthetic-life-worlds orchestrate linguistic and sonic transnational Caribbean migratory and diasporic crossovers that are informed by an enmeshment of Blackness, Brownness, Indigeneity, and queerness.

These intercosmic stylings are queer gappings and mappings
that undo the colonization of, and the race for, space.

As she vigorously touches other modes of difference and genre, Indiana communicates the full mobilization of queerness. Or as Eve Sedgwick claims, the term queer may apply to "the open mesh of possibilities, gaps, overlaps, dissonances and resonances, lapses and excesses of meaning when the constituent elements of anyone's gender, of anyone's sexuality aren't made (or *can't* be made) to signify monolithically."[172] The use of queer gaps and overlaps as method to disrupt the monolithic makings of subject formation animate a monstrous type of dissonant resonance in Indiana's writing and music, imbuing her entire body of migrating work.

In deforming form with this definition of "queer," we are reminded of what has too often been lost in queer studies today: "that queer is not a label"[173] as terrorist drag performance artist and icon Vaginal Davis might say. It is, instead, an intergalactic choreography of mess, use, and ceaseless flux performed in the disidentifying blur, in Indiana's fade in and out of desire across style, category, nation, and musical genre.

All key and chord changes in Indiana's art are alterations for life's ongoing queer compositions, in which her expansive cartographies acknowledge the intervals within the aesthetics of cognitive mapping.

This is "the time to return," in Indiana's resonant call, to Armstrong's cognitive musicianship and writing, collaging, archiving where cognitive mapping performs *as* gappings "because the music *already is* criticism."[174] Critical of written scholarship on music that thinks the writing of musicians as supplemental to, or *like* their sounds, Brent Hayes Edwards argues that music itself produces thought and rearranges the production of knowledge.[175] The use of the writer, the use of sound, the writer's, musician's and sound's usages, in all their gappings, reorient newly deranged orchestrations. These twists and turns make queer use "audible."[176]

If to orchestrate implies an audibility that escapes functionality, then at the heart of the rearrangement of aesthetic cognitive matters exist questions surrounding the performativity of orchestration. In their shifting structures, the orchestrations inherent to formless formations practice "queer use." These vital practices of misuse are vibrant animations where to queerly orchestrate is "the work you need to do to be."[177]

For Sara Ahmed, to queer use is to promote and engage in a vandalism that refuses "to use things properly...."[178] The vandalizing orchestrations innate to the aspirations of formless formations are, following Ahmed, aware that the "demand to use something properly is a demand to revere what has been given by the colonizer. Empire-as-gift comes with use instructions."[179] Thus, anticolonial direct actions are about taking risks that put queer use to *use* in

order to imagine and move beyond formal colonial instructions (and mere critiques of them).

The contingencies of risk create new potentialities that provide ways "of making connections between histories that might otherwise be assumed to be apart."[180] For Ahmed, this queer use of history and form endeavors against the "weight of history" and the ongoing institutionalization of colonial use instructions for thinking. The risk taking involved in the queer uses of thought helps cultivate divergent aesthetic-life-worlds, bringing the coordinates of different artists, thinkers, Indigenous and diasporic revolutionaries together into a formless formation.

Queer use then is always about a direct action that "depends on other prior refusals: a refusal to empty oneself of a history, a refusal to forget one's language and family, a refusal to give up land or an attachment to land, a refusal to exercise the terms that lead to one's own erasure or, to use Audra Simpson's powerful words, 'a refusal to disappear.'"[181] Let us not forget how Indigenous Action's own refusal to forget points to how their ancestors "understood that the apocalyptic only exists in absolutes ... dreamt against the end of the world."[182] Dreaming against apocalypse, queer use, in its collapse of absolutes, turns to disidentification and refusal as strategies, in which the refusal to disappear is to also dismiss the ingestion of "what would lead to your disappearance: the words, the ways; the worlds."[183]

Colonialism wipes out the extraordinary possibilities of other doings, ways, and worlds, as Césaire attests, by enforcing proletarianization, labor and commodification, property and propriety as use instruction. If queer use is the refusal to ingest things, then it is also always about how things are attended to, the ways in which

convivial research and study "linger on the material qualities of that which you are supposed to pass over."[184] It is also as Ahmed suggests: "to *recover* a potential from materials that have been left behind, all the things you can do with paper if you do not follow the instructions."[185] The formless formation, in its aesthetic cognitive mappings and gappings, declines to ingest and follow the use instructions of empire.

The alternative cartographies and direct actions enabled by algorithmic hacktivisms and transnational conversations and alliances – the misuses of the typewriter, trumpet, and trombone and the queer use of the voice and language – all constitute an activist archive that "might come into existence because of a gap between what is and what is in use."[186] The refusal to use something properly, to be impressed by the colonizer's words and things, maps, genders, and sexualities, is to also queer this gap "by finding in the paths assumed to lead to cessation a chance of being in another way."[187] Indiana's monster migrations and Armstrong's gappings as queer use, teach us that the aesthetics of cognitive maps are contingent upon on the aesthetics of cognitive gaps.

Queer orchestrations are mobilized only when the gaps between inseparable differences are sensed, put into play, and overlapped, for without a reverence for gappings there would be no traversing resonance, no unsettling of settlement, no open mesh of extraordinary possibilities for the coexistence of particulars.

DIMENSION

"**W**hat time is it on the clock of the world?" asks Grace Lee Boggs.[188] Taking a long view of the chronicles of humanity on our rotating planet, Boggs traces the ever-changing faces of revolutionary historical time on a linear chronometer. She warns how, as the clock ticks, social change urgently necessitates the eradication of external and internal capitalist structures and values. "Visionary organizing"[189] moves away from mere protest to a radical social re-organizing, a total re-imagining of world orders.

Yet the question "what time is it on the clock of the world?" sounds like something other than historical progression. It seemingly invokes the coexistence of multiple overlapping durations shooting off in and across infinite dimensional tangents. Time and space collapse because "the clock of the world" sounds more like planetary resonance. Inseparable from discernable phenomena, imperceptible things and their ephemera simultaneously exist in dimensions unknown.

Sensing multidimensional times and worlds requires the elimination of repetitive modes of linear and transparent representation. Whether located within historiography, state logic, or quotidian life, representation determines and demands reproducible structures. Performing dimensionally, but evolving unilaterally, representation's chilling inscrutability requires us to imagine what it would mean to be understood outside of its determining systems.

An acknowledgment of dimensional complexity is to recognize the simultaneity of many times in many worlds where progressive representation is not the defining outcome of revolutionary existence. Drawing from Gayatri Spivak, the authors of *The Undercommons* remind us that the first right is the right to refuse what has been refused to us.[190] Such a refusal may aid us in withdrawing from calcified annals, politics, temporal and spatial dimensional objectives. Representation is often mediatized as a hollowed-out signifier, a simulacrum that operates like a reproduced portrait, a likeness in shape that recalls something but never the matter. From some gallery walls to all police headquarters, most sketches are circumstantial reductions that superficially aim to catch and sell what eludes apprehension. This dimension of images, unfortunately, is also in control of many repetitive forms of organizing. Even resistance comes to understand itself via representation: we are what they are not; and they are what they will never be. Power purchases this almost-entity where the human=thingification.

Thus, representation can often be a murderous trap. For every institution is ruled by the institution of representation, which is in turn inseparable from the institutional reproduction of historical anti-Blackness and anti-otherness.

Attacking and dismantling such Western overrepresentations, Sylvia Wynter calls for the importance of "waking up our minds" via an anticolonial reading practice.[191] As she notes, colonial education insists on attaching scientific classifications of human being to conceptions of Western man; these categorical representations lead to multiple catastrophes conditioned by the foreclosed acceptance of categorical existence: "All our present struggles with respect to race, class, gender, sexual orientation, ethnicity, struggles over the environment, global warming, severe climate change, the sharply

unequal distribution of the earth resources [...] these are all differing facets of the central ethnoclass Man vs. Human struggle."[192] Shored up via the conveyance of scientific knowledge, ongoing disasters are accelerated by Western constructed categorizations of "human being" and their perennial institutional measurements and reproductions.

Wynter's countering anticolonial mode of intellectuality understands and emphasizes "being human as praxis" and calls for the necessary re-enchantment of this praxis, a re-enchantment made possible through a new science and inscription of form itself.[193] Drawing on Césaire, she reminds us that: "Human beings are magical. Bios and Logos. Words made flesh, muscle and bone animated by hope and desire, belief materialized in deeds, deeds which crystallize our actualities [...] And the maps of spring always have to be redrawn again, in undared forms."[194] Undared dimensions disregard colonial and capitalist forms, being human as enchanted compositional praxis expresses the crystallizing magic of inventive existence.

The anticolonial praxes of the constantly redrawn formless formation are ones that recognize the figure of the human as co-relationally *bios* and *mythoi* (biological and cultural) — a creative, organic, fleshly, cognitive being that "*authors* the aesthetic script of humanness."[195]

Troubling the division between science and creativity, Wynter turns to the cognitive leaps that connect Black creativity and differently imagined scientific knowledges that offer open and incomplete conceptions of being human. In her critique of scientific racism, Wynter insists on moving away from the overrepresentation of Man even as an oppositional category that determines resistance

itself. In other words, what would it mean to attend to creative works that are not invested either in an accepting adherence to, or the simplistic oppositional refusal of, the overrepresentation of Man?

In her study of the re-enchantment of "being human as praxis," Katherine McKittrick traces the ways composer, songwriter, and guitarist Jimi Hendrix performs the creative work of a co-relational *bios* and *mythoi*, a "science-ing of the biological contours of the human."[196] Hendrix's cosmic sounds unleash "a newly tilted axis," where the scientific axes of being human overlap with undared sonic forms in the technological present, providing in their sonorous opening of closed compositional systems "a poetics-politics of future love."[197] Listening to Hendrix's axes in his 1967 studio album *Axis: Bold as Love*, (also the title of her essay), McKittrick understands Hendrix's inventive manipulation of the guitar's sounds as one that allows for the "alterability of humanness."[198] The authoring of aesthetic scripts to re-write scientific delineations of being human is the creation of new dimensions removed from binaristic existences. Hendrix's resonating auralities are creative acts of undared forms rebounding across multiverses of metamorphosing (pr)axes, technes, and feelings.

The formless formation affirms the re-enchantment of life as ongoing magical multidimensional invention and (anti)foundational noise making.

In turn, the colonizing force of capital's modes of overrepresentation determines "value" and seeks to consume all noisy obscurity; it grows and profits by turning invention into profitable innovation, forcing reproducible representation on all innate surplus. As Marx shows, value is not a thing, but a set of social relations.

Manifested between the labor of different individuals working under a generalized system of commodity production and exchange, value "is nothing but the definite social relation between men themselves which assumes here, for them, the fantastic form of a relation between things."[199] Value as a fantastical relational form, and its material representation in money, is a capitalist process socially determined by the correlation between the purchase of labor, power, and the means of production.

The production of calculable value in the universal form of numeration must always reproduce itself in the name of reproduction: "Capital is money, capital is commodities. By virtue of it being value, it has acquired the occult ability to add value to itself."[200] Money is the material representation of value; if there is no market and no purchasing power, there is no value. This looping contradiction is in essence the capture of social relations and the disintegration of all human and more-than-human ecologies outside its materialized one-dimensional overrepresentation and dominance.

The internal contradictions of capital reveal the inherent multidimensionality to the one-dimensional spiraling of capitalist accumulation.

Capital's one-dimensional representational power is marked into materiality. Re-enchanting anticolonial (pr)axes are necessarily betrayed because an adherence to capitalism's dimensional orders is too often the only path for survival. Dollars, cents (sense), and numbers represent our exhaustion. It is imperative, as Wynter says, that "the buck stops with us."[201]

If, as the clock ticks the buck must stop, then in their fantastic formlessness non-capitalist organizations require philosophical

conversations regarding the imagination's role in configuring and arranging the aesthetic scripts and revolutionary practices necessary for addressing material needs and conditions. But they would also necessarily entail philosophical questions regarding the dimensional overrepresentations of historical time, matter, and space altogether.

In other words, how are both established capitalist forms and oppositional anticapitalist aspirational formations respectively propelled, managed, and curtailed by temporal understandings that are in themselves colonial? How are the past and the future in the present clock of the world? How is the colonial a "project of temporal looping" and "an active state in the here and now, looping forward and back into itself as if time never started or stopped ticking?"[202] Or how is the material experience of "ruination" lived as the processes through which imperial power occupies the present?[203] How are non-assimilating anticapitalist contemporary worldviews that escape representation always-already active in our capitalist present? These questions trouble a coherence only made possible by reproducibility. The conducive force of representation is linked to human historicity and the accelerations of accumulation.

The exhausting repetition of capitalism's historical hegemony demands a dismantling of its dimensional logics of space and time cracked open by resonance. In all representative systems, signs start and stop with us. Language is representational; all alphabetic scripts are forms of communication. Representation cannot disappear altogether. It is its prevalent rhyme and reason that must dare to change so as to make space for all possibilities in dimensions unknown.

As the title of one of Sun Ra's albums suggests, the unknown is witnessed in the *Sunrise in Different Dimensions*. Ra notes that "nature never loses anything."[204] Convinced that the unknown is outside of repetition, he states "history repeats itself over and over, but a sunset does not repeat itself, a sunrise does not repeat itself."[205] Planetary rotations repeat themselves in subtle or sudden difference; omniversal resonances are part and parcel of multiversal existences and their details remind us that yesterday is never exactly today. Found in the changing depths of the horizon, the light against the skyline, or the glinting color of the ocean, are the shimmering ephemera of constant dimensional difference.

Ra's philosophy of the unknown is one that requires knowing the unknown. To put it another way, capitalist biopolitical and necropolitical representations of life and death are stuck in a looping desired future that immobilizes subject transcendence for subject transparency. Their obsession is actually a love of power in the name of death with the face of life. The formless formation moves to the future of the future, the past of the past: what happens after you have imagined what will/will not happen, what did/didn't happen? This moment is called for by Ra in his poem "we must not say no to ourselves" in the collection *The Planet is Doomed*.[206] A call for the necessary synchronization and resonance with a "greater deed," an "art-wise dignity," "across the thunder bridge of time," "we rush with lightning feet," "to join hands with those, the friends of seers who truly say and truly do."[207]

In joining seers and doers, we land on the poetry of many, including Youmna Chlala. In *The Paper Camera*, Chlala reorients our reading practices by situating herself in multiple synchronous dimensions, globally and locally, and boldly declaring: "I am writing to you from the end of the world. You must realize this."[208] In a prophetic turn

of verse, Chlala's untitled poems perform as formless formations for friendship against the brutal doom of capitalist development, global resource wars, refugeeism, and forced migration. For many, as Chlala hints at, the end of the world has always-already been available; the everyday is a combative and constant disruptive situation[209] amidst quotidian emergencies born from the deathly maneuvers between clashing overrepresentations of Man.

Such crises inevitably lead to questions of form, imaging, representation, and their rooted correlations. The relationship between image and text and their ability to touch someone beyond the shutter of the page is at stake, as the title of her poetry collection suggests. Making friends with words and images, her "paper camera" attempts to capture the moment always passed and still to come. Chlala's poems add layers of different temporal and spatial dimensions and perspectives onto and into the surface of paper.

As her poem below expresses, a photo is both a friendship and its documentation. Interplay and interchange occur between words like "imagine" and "image," where the thought leads you to matter and then lands you on "form" as a structure for friendship across different dimensions.[210]

To imagine
take an image *tasawar*:

conceptualization

(derived from *soura*)
form

photo
sadaqaa: affirmation of friendship, state of believing

Chlala writes in sparse lines amidst large negative space to indicate openings for feelings, thoughts, and to form intimacies in the gaps between line breaks. Moving between Arabic, French, and English, her poems, like the one above, are motivated by syntactical wordplay, deep utopic sentiment, deliberate translations and definitions, and code-switching. Chlala's book imagines different forms across formless bonds of conversation, translation, and intimacy that manifest across words, punctuation, line spacing, and the distance between subjects.

All these different poetic, linguistic, formal, and affective dimensions cut across each other so as to dodge, flee, hold, and also let go of all demands of representation. Chlala's poems perform tectonic shifts and continental, regional tensions that in their discrepant engagements and creative enchantments cultivate undared forms across affirmative axes of friendship and faith. She creates images and words in a ceaseless interval and break against measure.[211]

In a constant state of intermission, the artist takes photos of her body as if she knows it will soon go. I have disappeared, present is as infinite, there is always construction going on outside, earth digging and jack hammers, to undo presence, myself as a timer—

The paper camera attempts to catch and present ephemeral life where human being is another aesthetic script of temporality and praxis. Chlala, in a constant state of intermission, takes pictures of her temporary body as timer, as it disappears into infinity so

as to counter the non-intermittent backdrop sounds of capitalist growth. In so doing, she traces another kind of clock and world.

In a plea for the rigor found in transient feelings and impermanent world makings, José Muñoz's theory of the ephemeral finds the enduring dimensions of the intermittent. Offering ephemera as evidence in order to disrupt the fixities of representation, Muñoz thinks through definition and genre; the hierarchies of academic rigor and conventional knowledge; queer methodology. He notes, "ephemera is always about specificity and resisting dominant systems of aesthetic and institutional classification without abstracting them outside of social experience and a larger notion of sociality."[212] Muñoz prescribes a radical critique of institutional systems, archives, and sanctions that expose how queer acts of and *as* minoritarian knowledge production speak to new ways of knowing, thinking, and doing. In rejecting dominant systems, the tilted axes and dimensions of the ephemeral resist traditional form, swaying across the formless in pursuit of all evanescence.

Muñoz cautions us to see that the formless is also in principle ephemeral. Incapable of separating social life from politics, aesthetics, and this renewed project of epistemology, Muñoz alters the entire landscape of reproducible and repeated representation. He elaborates that "ephemera includes traces of lived experience and performances of lived experience, maintaining experiential politics and urgencies long after these structures of feelings have been lived."[213] These ever-present traces, sensed in their socially vital afterburns, demand a rereading and rewriting of the protocols of critical reading and writing itself.

The nebulous and yet fully material dimensions of ephemera thus provoke a necessary critical rereading and rewriting of value form

as well. If "value cannot exist without its representation" and a regulatory norm can exist only when commodity exchange has become a "normal social act,"[214] then the recognition of ephemera as evidence, made apparent precisely because of queer social exchanges, is inseparable from an overturning of value's representation. Such a recognition allows for the force of creative sciencings to sound out alternative spheres of exchange within the sciences and technologies of capitalist accumulation. Hendrix's opening of closed systems and Chlala's machinic paper camera, provide other creative forms of value and social reproduction. Their aesthetics script new sciences that perform the unceasing possibilities for the alterabilities of humanness.

Words and sounds made flesh materialize "deeds which crystallize our actualities,"[215] actualities that noisily and poetically disrupt the embedded regulatory norm of value across spheres of exchange. This is why, as Wynter attests, the buck must stop with us.[216] The questions of value form and "creative forms" are inseparable. Thus, the aesthetic scripts of humanness will always escape their numerical measurement and representation because they are ephemeral.

Spheres of exchange across different registers of value alter circulation processes within capitalist conditions. Such anticolonial and anticapitalist (pr)axes instill newly tilted axes, values, representations, and dimensions. The creations of Wynter, Chlala, Hendrix, and Ra attest to the importance of imaging and manifesting new sciences, new aesthetic modes of inscription and sound, undared forms.

Ephemera is not one-dimensional evidence: its lingering fleets and feats glimmer across multiversal presences, even in the

para-presence of an insinuated absence rebounding in a shadowy illumination. Lived experience in all its ephemeralities is not antithetical to circulating information but an essential feature of how one comes to envision study. And study can be found in anything, from the vitality of a porous rock to the vibrancy of plants and sentences, to all matter.[217]

Study as material ephemerality is also an intention for crossing over, not just through time but within it, in all temporal-spatial positions allegedly unavailable but cognitively and aesthetically seized. With metaphysical thinking and in ethereal sentiment, remembrance is like a foreshadowing, a motion forward in its past, and a movement backwards in order to touch the horizon of the otherwise materialized. To travel this way one doesn't evolve by walking through open doors, but by becoming a varying breed of ether that allows the living to dissolve themselves through walls of closed passageways. This evaporation is the recorded disappearances and appearances of all existence, in which every ounce of matter bespeaks the aesthetic scripts of unknown profundity.

The multidimensions of material liberation resound a score that vibrates across planetary scapes and scopes, generating solidarity out of compositions from the differentiated labor that causes the world to revolve in frequency. A breaking of dialectical time, overrepresentation, and captured value, this is the insurgent clock of the world . . .

ADDITION

The revolution is elemental, multitudinous, conjoined, and alive. Everything small carries energy; everything seemingly tiny is an extension, the "subtle beyond" of a larger magnetic force. In these overlaps, dimensional worlds upon dimensional worlds escape representational capture and meaning. Only resonance lingers in the cuts of uprising, so listen for the touch, the splice, the addition, for it is a virtual particle of the void and the void itself, in which to touch the self is to touch the other through infinity, a "cutting together-apart."[218] This materiality of touch is a formless formation that in its constant process of addition flees from the demanding structures of thought and representation.

The marriage between systems of representation and architectures of knowledge makes it difficult to decipher their singular intentions. There's a connection between knowing and the elemental paradigm of identification that representation upholds. Often, and unfortunately, representation serves as epistemology itself, making it unclear how the uses of knowledge are rationally defensible.

In submitting to the designs implicit to cultural forms, structuralist thought accepts their logical presuppositions. Post-structuralist thinking, on the other hand and in its most basic sense, contends that all forms are socially, culturally, and politically conditioned, and that the only way out of their organizing maze is to unfollow

the labyrinth's twists and exits.

> For as principles of assembly teach,
> the word form still lives in the term
> reform.

Forms, and other structuring ventures, are not reliable conveyors of information, rationality, truth, justification, and meaning since systems are culturally determined. For study is a dimensional continuum that one imagines, conjures, proliferates as much as one feels across cultural interpretations, styles, rhythms. In challenging instead of integrating pre-existing bodies of knowledge, one embraces the materiality of touch through the addition, both felt and sensed, by seeing its evolution as essential to meaning-making.

In search of a materiality of touch that outpaces structuralist tendencies, Roland Barthes appropriates systems of knowledge to remake them. Of particular interest here is Barthes's *Camera Lucida*, a series of overlapping vignettes, published in the same year he died and three years after his mother's death. This two-part text is an intervention in the philosophy of photography as much as it is a reflection of love and despair, a eulogy in the shape of a son's grief, and the slivers of essence exceeding systems of knowing, frames for seeing, and designs for feeling.

Barthes begins this book with a clear use of semiotics: terms upon words reiterate structuralist systems meant to define the smallest units of meaning; signifier upon referent, Barthes engages images by enacting a new philosophical vernacular to read them. Working from an assembly of signifiers, he underlines two properties of

the photograph: the *studium* and the *punctum*. [219] The former is
the cultural milieu, the mise-en-scene, the background we know
through education; while the punctum necessitates correspondence
between the image and the spectator. Not bound by education
or interest, Barthes's defines the *punctum* as the detail within the
photograph that pricks the viewer, pre-existing and eclipsing
the image and its frame. The punctum is a kind of addition; or
what the spectator contributes to "the photograph and what is
nonetheless already there."[220]

Propelled by the puncturing punctum, Barthes studies photogra-
phy as a wound that one wears on the body and also organizes as
a corpus/genus of knowledge. Bodies of both flesh and thought
become one as he searches for the ontology of photography found
in the very contusions of the viewer. In reckoning with this addition
as punctum, Barthes dubs it a "subtle *beyond*"[221] and suggests that
what we can't quite see with our eyes, we feel and know beyond
the bounds of touch. What does each image in its singular right,
Barthes wonders, represent if not the thing itself? Might the pho-
tograph be able to exist outside the boundaries of representation?

The punctum lives outside conventional notions of reproduction,
for if we collectively give life to an image that was always-already
alive, then the addition exposes our entangled shareability and
ongoing conspirations. In search of the punctum's considerable
energy, Barthes adds that it is "as if the image launched desire
beyond what it permits us to see: not only toward 'the rest' of the
nakedness, not only toward the fantasy of the *praxis*, but toward
the absolute excellence of a being, body and soul together."[222]

Unable to withstand the protocols of rigid forms, of reading images
through an objective lens removed from others, he unleashes form

from its own structuring principles and affectionately succumbs to feeling. If the punctum exists in the "subtle beyond," then Barthes in part two of *Camera Lucida*, embraces the additional beyond through the death of his own mother. The unbearable loss of his mother leaves him forming and deforming emotions and pragmatisms in search of the forever present-absent figure. Regrettably, a remaining photograph of his mother as a child, which he describes in detail but refuses to visually reproduce for the reader, cannot accurately highlight her essence. In denying us the "Winter Garden Photograph" and the opportunity to signify meaning through signification and reference, he counters structuralism, proving instead that dissent, formlessness, and loss accompany one another.

One does not reform form, but formlessly apprehends formation, even when one's mourning carries the traced tenets of ephemeral existences.

In confidence and grief, Barthes declares that the photograph of his mother, "exists only for me. For you, it would be nothing but an indifferent picture."[223] Sharing her photograph will not allow one to know her as he does, or help him put her to rest, for the punctum is everything inside and outside of death, every feeling the addition shelters when the materiality of touch escapes the present.

If "photography is subversive not when it frightens, repels, or even stigmatizes, but when it is pensive, when it thinks"[224] and punctures the spirit, then the photograph is a living image, maybe even a wound, revived by the belief that in erupting all form one reaches the edge of the edge. The subtle beyond, in all its formless formation, is what one brings to the scene but is already there, present, but outside the frame's position of power and desire.

Outside representation. Outside structures of knowing. Outside death. This is the addition.

Following this desire to land in the realm of "the absolute excellence of a being, body and soul together,"[225] the addition includes everything outside the frame leading us into the internal traces of touch, the volume of excess.

The subtle beyond happens outside the frame, inside the human, in the reader, through the spectator; it is a transformative process induced by details known and unknown and methods of desire that activate engagement. Deciding when the writer has said something, the reader is the addition to the writer and the writer the addition to the reader, in constant flux, gaining, as Barthes's notes, all the pleasures of the text that outweigh conventional meaning.

Found in the cuts, tensions, discrepant encounters of meaning, the reader like the viewer is the deconstructor of the word and the world in order to sculpt new ones.

Every detailed trace of the beyond is found in the harmonized cracks left to be tremored, left to be invaginated.

Jacques Derrida's poststructuralist deconstruction of the Eurocentric human sciences tears down the institutions upheld by their language, discourse, conventions. But as Spivak notes, "It's not just destruction," but also a form of construction. "It's critical intimacy, not critical distance."[226] In learning to speak from the inside, deconstruction as critical intimacy is the performativity of addition in which the seed is modal and the expansion of the supplement. Building on these observations, the addition functions as an operation, one where to add is to be inside as

opposed to presuming an outside stance that purports to add separate things together.

Invagination is the process of turning something inside out to make another hold, another (w)hole, another fold out of resonance. In other words, this folding in for Derrida is the process of identities emerging out of difference, where difference itself has no stable identity. His neologism *différance* writes out difference itself – the difference and deferral of difference – by weaving together traces that have no beginning or end.[227] Like the punctum, exceeding and surpassing the frame, the trace, too, denies the linear construction and envelopment of existence and meaning.

Derrida notes that *"différance* is the systematic play of differences, of the traces of differences, of the spacing by means of which elements are related to each other."[228] This constant play of difference is where things emerge, rather than existing prior to difference's emergence. Or as Derrida claims, "this spacing is the simultaneously active and passive production of intervals, without which signifying terms would not function."[229] That is to say that the trace of what things are not is what gives them their identifiable presence.

This is nothing less than the question of being itself, for as Derrida reminds us, building upon Heidegger's corpus, the question of being is the inaugural question of Western philosophy. Critical of the idea that the present particle of being exists in a modality of time that is sensed as the presentness of presence without trace, Derrida considers what comes before the philosophical question: "what is being?" For there must be an affirmation of traced being in order for this question to be posed in the first place. He "reinscribes" and "displaces" the question of the presence of being as positioned by Heidegger,[230] by turning to the trace in writing.

In language, a weave of traces is the condition for the signified and referent to communicate as their identifiability depends on their relation to other signifieds and referents, and the intervals between them. Always emerging from shared structural traces, the performance of difference is in all things and all relations; it is a "rapport" that refers to the traces internal and external to identities indefinitely formed through and as variation.

Rapport is another word for additional resonance, where the trace and the interval are evidence of both the presence and absence of presentness.

Derrida emphasizes that the past and future are in the present, and yet are not present in the present because the "trace is not a presence but a simulacrum of a presence that dislocates, displaces and refers beyond itself."[231] He goes on to add that the trace itself is a non-place because "effacement belongs to the very structure of the trace."[232] In putting into question the presence of the present, the trace is an "anterior acquiescence,"[233] an affirmation that in everything there is a return and departure to something else, or a future beyond, another subtle temporality through the rapport with *an* other and *all* others.

If "being is trace-being,"[234] and the trace is experienced differentially and indirectly, then deconstruction is at once a subtracting addition and addition subtracted. Identity has no being outside of "trace-being," which is always-already determined by a different difference. This is the additional operation of the formless formation as a web of traces. Its identifiable entities are felt present through their innate traces, intervals, and shifts operating as integral relational differences.

Such rapport with and *as* the addition includes not only what the reader brings to the text but how the writer sees themselves as a reader as well, how thought itself traces relational presences and absences. Barthes's "subtle beyond" and Derrida's trace "beyond itself" include not only the composer/writer but the reader, a sensorial entanglement that surpasses its own indexicality.

If the subtle beyond is what one brings to any scene that is also always-already present, then the extension of feeling one contributes activates this sensorial entanglement. One's emotional history is not an accessory to the mise-en-scene of reading or viewing, but enriches the worlds produced by the composer/writer. Viewing and reading, like writing, is a wound we afflict and suffer together.

> If writing is a communal bruise, a relation, a
> constructed deconstruction, then
> the addition expands the idea that
> being within/of the text is to also
> be of the world.

Poet and novelist Ocean Vuong shares that writing is never removed from one's cultural flights. In a book about migration and refugee subjectivity, Vuong parallels dispossession with the saving grace that is writing. If countries carry symptoms and sentences, he asks then "what is a country but a borderless sentence, a life?"[235] In personifying discourse, Voung entangles the webs of life and narrative by writing out the details of both, even when the structures of knowledge exclude him. Writing from a space of forced migration into the material consequences of ideological representation, Vuong answers the above question with another question: "What is a country but a life sentence?"[236] If belonging

to a nation-state also means to do time, then writing is a constant influx and efflux[237] of inseparable internal and external circumstances. A fluctuating scene that Voung negotiates into the script of writing, and by consequence, world making into life sentences.

His aforementioned questions encapsulate a form of migration that disappears the border through the metaphor of transient sources and also identifies the temporal and spatial conditions of writing. In his commitment to the sentence level, Vuong subverts the absolutism of form through new autofictions, the epistolary novel, citational practices, and a series of borderless vignettes that author the aesthetic scripts of the human, of all life.

In challenging the linear temporality of existence, Vuong argues that "if we are lucky the end of the sentence is where we might begin."[238] In beginning at the full stop, with a commitment to the trace, Vuong conditions our relationship to reading: everything not written might also be the life of the sentence. He elaborates that "if we are lucky, something is passed on, another alphabet written in the blood, sinew, and neuron; ancestors charging their kin with the silent propulsion to fly south, to turn toward the place in the narrative no one was meant to outlast."[239] Writing to outpace his own death, Vuong's "writing sentence" is a love letter to all who can read and those who never learned, all shapes of readers are implicated in his account of doing time with discourse. This expansive readership includes his illiterate mother, his belated grandmother, all the men he loved and couldn't carry, and his younger self that he learns to befriend and outrun in order to survive the life given. Even if it is a version of an existence breathing across fleeting paragraphs and multiple denouements, it is one worth experiencing in full historical and ancestral resonance.

Vuong's writing sentence, a play on serving time and surviving the phrase, implicates more than just the readers named above, but familiar writers, who in similar vein, understand that existence, like writing, not only passes, but is passed on.

Throughout *On Earth We're Briefly Gorgeous,* Vuong passes down his own subtle beyond as embedded in storytelling, in the bond between mother and son. If "memory is a choice"[240] and writing exceeds the very sentence, then Vuong willfully uses citation as the evidence of the materiality of tracing touch. Barthes's writing on the personal effects of mourning fills the pages of Vuong's novel; he's a syntactical ghost that declines to die with the mother, the text, the sentence. As Voung remembers Barthes, he records his own loss and triumph and explains that the mother's body and writing with/for/into the mother are inseparable entities, all writing is an opportunity to impair and also "change, embellish, and preserve" the mother "all at once."[241] This is all to say that a novel about migration and forced expulsion is also an ancestral story about how one tells the story, none removed from the losses experienced before the word hits the page.

Writing with formlessness rebuffs capture by way of the materiality of process and the rapport (or resonance) with others and other times and spaces. The constant construction and deconstruction of difference, through modes of storytelling, emerges in the intervals of social motleyness and in the cuts to other voices that in their own loss cite a flock, reference a crew.

To abolish form you need a crew, mostly motley, and certainly always ready to orchestrate into other worlds. For the rapport with something/someone else is part of social organizing, or what Laura Harris calls the kaleidoscopic category of the "mot-

ley crew."[242] For Harris, the resistant, improvised, and fugitive ontological dimensions of the motley crew are bound up with the "aesthetic sociality of blackness."[243] Directly responding to the work of Marxist historians Peter Linebaugh and Marcus Rediker, who trace the emergence of "the Atlantic proletariat of the seventeenth, eighteenth, and early nineteenth centuries"[244] and mourn its demise, Harris traces how the connections that form motley crews from disparately dispossessed peoples are ongoing. Harris expresses that it is precisely the problem of thought generated by categorical thinking (i.e. Linebaugh and Rediker claim that the motley crew disappears with the emergence of racial capitalism's more institutionally structured categories and separations), that blinds the historians from discerning extant motley crew life and living.

Forming a distinct motley crew in her own book, Harris studies the works of Trinidadian C.L.R. James and Brazilian Hélio Oiticica to uncover how both James and Oiticica engage in the creative sociality of Blackness formed by a motley politics and aesthetics. In doing so, she brings our attention to *forms* and *methods* of the motley crew's insurgent study and experimentation. For example, Harris places in conversation James's study of cricket and Oitici-ca's collaborative works in samba to expose what Iyer calls in his own terms "the athletics of black musical performance."[245] "The aesthetic sociality of blackness," in Harris's naming, "is an impro-vised political assemblage that resides in the heart of the polity but operates under its ground and on its edge."[246] She adds that, "it is not a re-membering of something that was broken, but an ever-expanding invention."[247] The aesthetic sociality of Blackness both includes and excludes the visual terms and engagements of Blackness in its ever-expanding invention of addition in order to survive its own conditions of racial capitalism. This in turn revives

and acknowledges extant motley crew lives, ones that never outrun their own traces, "trace-beings."

The motley crew is a mode of "intellectuality" that incorporates the full breadth of our senses and resistances. Between the contact as maneuvers of the motley and the priority of motleyness, Harris arranges a new methodology to engage diverse experimental encounters, challenge ideas of authorship, and attend to expansive modes of belonging across nation, race, gender, class, and sexuality. Harris's "motleyness" is our formless formation and resonance as methodology.

> Resonance is that moment of illumination, or the liberation one feels in the process of being discrepantly entangled with another in all motley encounters.

Part of following this illumination requires recuperative and revisionist histories that operate, without exception, in nonlinear time and anticapitalist anticolonial tenor. This tenor is cut with the impulse to deform form because even in the process of this attempt, the organizing structure of all social life is form itself. The indexicality of form is what mobilizes sites of divergence against categories of difference as its organization for difference.

How can difference breathe against its own taxonomical confinement? The answer is to be found within the crevices, cuts, excesses, senses, traces, and additions of the formless, the cracking and blaring of voices "where shriek, turns speech, turns song – remote from the impossible comfort of origin – lies the trace of our descent."[248] This descent is also our ascent, our addition, our tracing of the senses propelled by uprisings moved by motion.

Lines and breaks undone, all possibilities vibrantly fading into a howling whisper. All additions are the incremental edge surfacing within the motley crew.

Motley crews, however, must experience constant acts of internal retracing and examination if they are to survive their own difference. The theory and practice of motleyness is not an organic predicament, but a process that recuperates itself while in perpetual review. Or as Vuong fiercely conveys "every history has more than one thread, each thread a story of division."[249] That is to say that in attending to these divisions one notices that the variant silhouettes of the motley are best gleaned in the space of recurrent historical assessment, where the interval cuts across and threads new narratives and arcs.

The original Rainbow Coalition, for example, a multicultural movement founded in Chicago in 1969, and formed by Fred Hampton of the Black Panther Party, with the help of William "Preacherman" Fesperman of the Young Patriots Organization, and José "Cha Cha" Jiménez founder of the Young Lords, was a motley crew that forcefully articulated the awareness that capital relies on the separation of working people through the categories of ethnicity, race, and religion. Calling for the destruction of such categorizations, and solidarity between all working people across the US and the planet, these soldiers of love often foreclosed their own motleyness.

This is to specifically reiterate that the dissonance of gender, sex, and sexuality within these movements was central to their disintegration. The revolution wasn't thoroughly actualized (or televised) because patriarchy, machismo, heteronormativity, sexism, transphobia, and misogyny played major roles in the collapse of

the worker movements of all centuries. Lamentably, these systems of oppression seep into the very spaces of counter-culture and rebellion. For as Frantz Fanon proclaims, the conditions of colonialism are not solely binaristic (colonizer versus colonized), but a complicated landscape of relations in which the colonized, at times, become the colonizer to those similarly subjugated.[250]

A primary resistance to this may be found in the political labor of transgender activist Sylvia Rivera, a member of the Young Lords Party and its Women's Caucus, and a leading figure of the Stonewall Riots of 1969, who established the political organization STAR with Marsha P. Johnson, and was also the co-founder of the Gay Liberation Front. In reimagining strategies of Black and Brown revolution via a transgender analysis, Rivera built the first pride rebellion, listening for the chimes of difference to free her and comrades from the rattling sounds of sameness.

Rivera, like many others at the forefront of the movement, left the Young Lords Party because of a monolithic understanding of gender, sex, and sexuality. This departure was not one-directional however; Rivera also felt alienated from the whiteness and of transphobia embedded within the queer movement that equally oppressed subjects across racial and sexual identities.[251]

Let us remember a less than 5 minute black and white video of Rivera's inflammatory speech "Y'all Better Quiet Down," given in New York City in 1973 at the Christopher Street Liberation Day rally in Washington Square Park. From the stage, Rivera faces the ensuing boos of the audience and courageously rages against the crowd: "Y'all better quiet down."[252] But the riotous swarm persists against her call for solidarity and mutual aid. Swaying back and forth with microphone in hand, Rivera gathers herself against the

buzzing violence of the crowd: "I've been trying to get up here all day for *your* gay brothers and *your* gay sisters."[253] The heckling and hissing continue as she tightens her grip and screams even louder into the mic to challenge the deadly and obsolete categories of gender and sexuality.

In a move away from these dangerous categorical traps, Rivera calls for a new formless formation called STAR (Street Transvestite Action Revolutionaries), privileging a gender non-conforming and transgender activist *manera de ser*. Unable to understand the brilliant shimmer of her call, a wild bursting star in her own right, the crowd responds, "shut up" and "get off the stage,"[254] but Rivera refuses their admonishments as she shrieks against the queer community's silencing transphobia, toxic masculinity, and racist heteropatriarchy.

As the video progresses and the camera zooms in on her desire for more life and less loss, Rivera screams out an implicated *duende* that shatters the perfunctory ideas of queer belonging. "You all tell me, go and hide my tail between my legs. I will no longer put up with this shit. I have been beaten. I have had my nose broken. I have been thrown in jail. I have lost my job. I have lost my apartment. For gay liberation, and you all treat me this way?"[255] In this cry, Rivera expresses the subtle beyond of loss that accompanies the fallacy of representation for trans life. In demanding to be seen and heard, Rivera necessarily withdraws from implied negation.

Spliced between screams, Rivera's quivering sounds concede a type of punctum, or the vocal slivers of essence that transcend systems of knowing, scaffoldings for hearing, and designs for being and feeling. Her breaking voice declares the immanent potential of framing loss and losing the frame.

If the punctum is always the addition that is already there, Rivera is always-already here. One must refuse to know her within the totalizing frame of the image, and work to touch the cuts of her sonorous progressions, the breaks within her activist vocal and visual uprisings. For in demanding the right to exist in multiple, Rivera disidentifies with dominant constructions of form, originating a formlessness that is resonance itself. With fist firmly up and voice cracking into descent, Sylvia Rivera is the material memory of a soldier of love pulsating ideological solidarity.

Identity politics, as Rivera calls out, often deny that presence relies on the interwoven traces of difference, of multiple desires shared across disparate anticolonial and anticapitalist projects. This is to also suggest that the full potential of *différance's* resonance as innate addition, deferral, and subtle beyond is muted for the sounds of capital in its circulation. Rivera's shouting, then, is more than rebellion. It is life sharing, leaving traces of descent to both follow and unfollow.

Identity politics once meant "life sharing"[256] as described by the Combahee River Collective in 1977, a way to raise consciousness and access liberation from within both singular and intersectional struggles. Not surprisingly, identity politics has come to produce the very exclusionary tactics they hope not to repeat in acts of inclusion. This is to also say that a liberatory political force that begins with one's life coalesces with other lives always-already here.

Formless formations re-trace the addition that is "life sharing." In those fights against a "disembodied universalism" that attend to "the coexistence of particularisms,"[257] the edge is never just and edge, just as difference is never just an addition. Barthes's "subtle beyond," Derrida's "rapport," Vuong's "shared writing sentence,"

Harris's "motley crew," and Rivera's "shriek, turns speech, turns song," are all a gathering made up of the effacing traces of ancillary presences and absences.

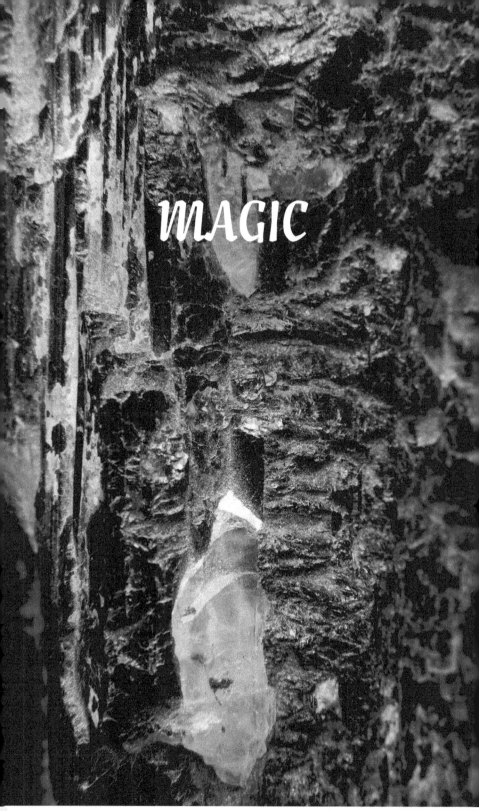

MAGIC

Astriking incantation, or a synergetic impulse between the known and unknown, elemental magic is like a social democracy gliding across enchantment, metaphysical sentiments of the earth. Every possible universe exists in the multiverse, every potential entity lives in a number of universes, all exchanges spanning particles and emotions.

Magic's thrilling intensity quells the quandary of everyday life, where the liberating chorus of the formless unshackles suppressive form.

The formless is more than a speckle of hope, dabbed and dusted onto the earth, but a groove one walks, imprints left on the ground; for in these traces, the fade conjures. This fade, its residual force, is sustained by magic, remnants that remap the globe from the depths of senses both felt and envisaged.

> Sometimes magic is an atom in the wind
> that brushes the heart on one's sleeve;
> a touch, that in its incommunicability, roars a
> world into existence.

Walter Benjamin writes that the shrilling bell derives its force from the magic of the threshold.[258] The magnitude is evinced in the exit of entry and the end of the beginning, a looping sensation that vitalizes transformation. Through euphonious reverberations, every evolution is an ethereal interlude and extension, fading from and into the multiverse. Magic is more than an inclination to sound out an ephemeral spell, but a declaration to stand up with fists raised against the open sky until the threshold complements its intention. Fading into life to life, these pulsating fists are the paradox of the ephemeral being materialized, where to fade-in is to also fade-with. Or to sharply fade into a movement amassed from the threshold of a people garnered from the luminescence of magic.

Cultivating an immersive liberatory landscape from the bells of magic, hip-hop feminist theorist Ruth Nicole Brown calls for the "creative potential of Black Girlhood," produced "critically among and with Black girls."[259] More than a celebration of Black girl visibility, Brown's body of work shifts our understanding of epistemology by exposing how Black girls, often erased from archives, have always generated rigorous thought by surpassing the boundaries of knowledge production. In 2006, Brown established the concrete utopia that is SOLHOT (Saving Our Lives, Hear Our Truths), a space of liberation and love that breeds new meaning by traveling across discipline, genre, method, pedagogy, and forms of creativity.

Honoring every kernel of thought rendered undeserving under systemic racism, SOLHOT is an independent enterprise in its own right. Moving across cultural sites like universities, elementary and secondary public schools, churches, afterschool programs and between creative work like theatre, poetry, ethnography, performance, storytelling, and music, SOLHOT requires that

we follow the inventive "trace of descent"[260] that stimulates new world mapping and making. Under Brown's direction, SOLHOT has produced albums, plays, novel forms of ethnography, while simultaneously blurring the lines between pragmatic thought and emotive creativity – neither one antithetical to the life of the other, but rather ideologically embroiled.

Like Wynter, Brown calls us "to wake up our minds" by theorizing creativity and accounting for its pedagogical and life-altering energy. Encouraging the formation of magical soldiers of love, SOLHOT is a call to arms via the aesthetic-life-world, all fists seen in the details of narratives untold. These untold stories feature heavily throughout Black Girl Genius Week (a yearly week-long SOLHOT invention and celebration that travels across the states off and online) where the creative labor cultivated and shared by and with Black girls is center stage. In striking fashion, event topics range from discussions of the politics of hair to Black feminist poetry to letter writing as pedagogical praxis to Black and Brown forms of aesthetic organizing to making live recorded music with an on-deck SOLHOT DJ.

Leaving no thought by Black girls unturned, Brown is a visionary of another time and place, a vision for and of the future who values all creation, both rehearsed and improvised. In fact, it is the very everyday improvised acts and sounds performed in the space of SOLHOT sociality that assemble the possibility of hearing truth in order to save one's life. This truth is bound to what Brown reveals about thinking itself: "research that is creative, public, and grounded in collaboration with marginalized communities, conducted by scholars of color, is always and already suspect."[261] Understanding that every form of knowledge produced by Black girls is always-already outside standard epistemology, Brown

devises new ontological breath for reading and listening with them. In such liberatory spaces, Black Genius is a privileged form of thinking that animates new constructions of Blackness, Black girl study, and existence.

While formally established fifteen years ago, Brown comments on the slippery nature of genealogy when work produced for and by people of color is suspended from archives, documentation, and funding. Part of this slipperiness, for her, is related to how these systems of knowing deny curiosity and creativity in order to uphold structure whilst still commercializing the moniker "Black girl magic." Brown's work rejects this reductive neoliberal representation for it overlooks the laboring genius embedded in Blackness. SOLHOT began before it began as a formation for a different kind of existence, one in which Black girls are fundamentally listened to by one another, even if the institution refuses the documentation of their voices.

In instituting against the institution, Brown knows that "what we learn in and out of sacred time, practice, and relationship is that we are certainly worth our own liberation."[262] "To be worth your own liberation," as Brown writes and shares with her students, is an act of love in the domain of fugitive planning, or an undercommons built upon the intellectual labor of Black girls, where creativity is freedom itself and Black girl gathering is the always-already necessary collective for a new social order. Brown generates spaces to listen with creative memories in order to from new knowledges toward the unknown, providing a path for how to listen with creative memories in order to form new knowledge toward the unknown. Not far removed from the political and aesthetic stylings of Afrofuturistic thought, Brown promotes an unknown where hip-hop feminist travels in space are the place.

Space is the place for misfit play, for imagining worlds otherwise unseen, but cosmically known. As Sun Ra's creative collectivity reveals, mysticism is misfitism. Myth is both play and the motley crew looking up to the stars and dreaming with glimmer. For as Ra espouses "the myth can do more for humanity then anything they can dream possible."[263] This is the adherence to a real myth working in tandem with the worth of one's liberation as Brown avows. SOLHOT listens for the planetary connections across time, space, and history like Ra vibrates an "Astro Black" mythology[264] moving from ancient Egypt and back into outer space.

The visual and sonic pulse of Ra's aesthetic-life-world works from and within the Black Radical tradition, even if one is not from planet Earth, and especially when the galactical soundwaves are infinite. Like Ra notes, the impossible is possible.

> From the depths of creative memory and curious methodology,
> the impossible is possible.
> The possible is an impossible possibility.
>
> The impossible is always-already possible.

Expanding the boundaries of thinking History beyond chronology, Ra is not the ostensible pathologization of some "galactic gobbledegook,"[265] but Black genius glimmering. His prophetic observations of space and time tour through omniversal vibrations that are now echoed in findings by contemporary astrophysicists, theoretical and quantum physicists. How these vibrations are sounded in the Sun Ra Arkestra's collective practice begs one to ask what these vibratory patterns say about history, time, planetary, galactic, and improvised social compositions. What does Ra

mean by mythocracy vs. democracy, or that "history repeats itself in ways that the universe never repeats itself?"[266] What is at stake in trusting that the world is the way it is because of "the scheme of words," as he writes in the poem "man and planet earth"?[267]

Sun Ra's and the Arkestra's artistry embody musicianship as spaceship, tapping into frequencies from sonically technological "crossroads whence dimensions meet."[268] How can we listen deeply to the ways that art is everywhere? "Every thing's vibration is a different degree of music,"[269] as Ra writes in his poem "infinity is the language." How is listening a kind of shattering? "Somewhere else on the other side of nowhere, there's another place in space, beyond what [we] know as time."[270]

From stars to dust to inter-gravitational forces and dark matter, there's more magic beyond the dimensions we will ever see and know.

There's no adherence on the formless formation's part to traditional constructions of time and space, but rather to how resonance replaces both as an organizing trope for the universe. As astrophysicist Manos Danezis insists, outside our limited perceptions the universe is formless,[271] or to put it another way, the big bang is the ever-moving extension and expansion of the big band!

Galaxies are always on the ground, flipped horizons hovering under our starry feet.

To time travel with other space travelers is to misfittingly read[272] and play with imagination's magical ability to transport readers and players to other worlds and constellations. Such articulations

of speculative futurity, as Alexis Lothian argues,[273] are not singular crossings, but traverse the boundaries of both science fiction and queer thought. Queer imagining, outside traditional structures of reproduction, always involves a futurity, while the "convergence of queerness and science fiction requires that neither one be defined in advance."[274] If futurity has already arrived, but hasn't been "evenly distributed,"[275] then the imagined futures of those precluded from futurity labor to dream queer possibilities speculatively.

One of many examples of such speculative and queer dreaming is N.K. Jemisin's *Broken Earth Trilogy*. Drawing us into fantastical worlds that are also eerily familiar, the first novel of the series, *The Fifth Season*, begins with the words: "Let's start with the end of the world, why don't we?"[276] Through evocative renderings and correlations, including those of imperialism, enforced labor, racial policing, and environmental disaster, Jemisin's story takes place on a continent named The Stillness that constantly and dangerously buckles and shifts in form.

The three key female protagonists of the novel are orogenes, known derisively as "roggas" (the three become one), and are born with the "the ability to manipulate thermal, kinetic, and related forms of energy to address seismic events."[277] Infants and young children, discovered to be orogenes, are captured by members of a type of police academy. These "Guardians" deliver them to the capital to be disciplined at the Fulcrum, an imperial facility for schooling the "savages" into submission while simultaneously training them to use their powers. For "any infant can move a mountain; that's instinct. Only a trained Fulcrum orogene can deliberately, specifically, move a boulder."[278] Once trained, orogenes are mobilized under surveillance to tap into and stabilize The Stillness's seismic tremors constantly threatening life.

One day, reaching deep into the magma of the earth, an orogene rebel breaks the planet, exploding the center to fade into the edge of something otherwise. This insurgent act of destruction seeks to abolish the governing system that capitalizes on the orogenes' power. The orogenes' innate gift of being able to tap into all elements, seams, and forces of the earth's landscape is one described as "magic." This magic is the orogenes' ability to connect with and intricately manipulate all material life forms. As there is no separation between their sinew and the world, theirs is a quantum flesh.

Jemisin lends us the orogene's quantum flesh as a reminder of the formless inseparability of all connectivity. When the disobedient orogene shatters the world, his fracturing is at once inseparable from the earth and the desire for another social order. Apocalypse marks both the end of the world as well as revelation.

Listen to the sounds of the big bang's and the big band's shattering propulsions.

In deep resonance with Wynter, Brown, Jemisin, and Sun Ra, Octavia Butler also blasts open humanity's constitution through radical revisions and revelations. Butler's uncategorizable novels and short stories imagine alternative embodiments, temporalities, and cosmologies in order to grapple with histories of racism, sexism, xenophobia, the ongoing threat of looming apocalypse, and the very category of the human body itself. Her works are queer speculative tales, changing the sciences of human structure in which flesh itself is *always* scripted as an undared form.

In Butler's first book of the *Xenogenesis* series, *Dawn*,[279] Lilith Iyapo wakes up in an alien spaceship after a nuclear war and the annihi-

lation of planet Earth. Eventually she communicates (cognitively, communally, and sexually) with the alien species Oankali and Ooloi that have saved her from her destroyed planet. Lilith's story reveals the ways in which the human body is biologically altered through its contact with the aliens. This is what Butler means by "xenogenesis," the alteration and generation of a newly formed human body through its physical and cognitive communion with an alien other.

The Oankali tell Lilith that humanity's defining contradiction is that human beings put their intelligence to work in the service of hierarchy. For Butler, this contradiction generates the constant terror of institutional brutality and planetary doom. If "being human as praxis," as Wynter notes, relies on the dismantling of hierarchical overrepresentations and the creation of undared forms, Butler's genius is the authoring of aesthetic scripts for unexpected reconstructions.

Butler provides the genesis of a socially formless formation in which human relation to changing worlds is constantly rethought. For as critic and artist Kodwo Eshun notes: "The question of xenogenesis can be understood as a kind of diagramme for the revision of the human."[280] Butler's intervention is to share with readers of *Dawn* and other novels such as the *Parable* series and *Fledgling*, the vibratory auguries of inventive imagination. For Butler, "all that you touch is Change. All that you Change Changes you. The only lasting truth is Change."[281] Her prophetic voice cracks open time and space, thundering across the perennial challenges faced by the world today. Her stories teach us about the ethical and physical claims of survival on the level of flesh and feeling (stubbornness, fear, desire, pleasure) in our apocalyptic present.

In showing how "the human or humanity is a revisable project,"[282] the magical powers of Butler's interventions uncover how racial, gendered, and corporeal classifications are reproducible fictions and thus always modifiable. Butler's cosmologies inform our current questions about political imagining and organizing, operating as a model for grassroots activism, and emergent strategy for change.[283] In her fictional work, change is one that either looks to the stars, or travels far back in time, undoing the linear project of temporality.

But change is not without painful ruptures sedimented into our historical bedrock. Walter Benjamin writes that "[t]here is no document of civilization which is not at the same time a document of barbarism."[284] And crucially, "barbarism taints the manner in which [documents are] transmitted from one owner to another."[285] Or as Rammellzee, another vital maker of magical aesthetic-life-worlds asks, "who put us in a race and for what purpose are we racing?"[286] Butler's novel *Kindred*[287] provides a response to both Benjamin and Rammellzee by telling the story of Dana, a struggling writer living in California in 1976, who finds herself traveling back in time and space to antebellum Maryland in the 1800s. When she finds herself there, Dana must do everything to survive the conditions of slavery. If she does not stay alive in the 1800s, she will not exist in the 1970s, because she has traveled through her own genealogical time to an ancestral past. Furthermore, she must fight to ensure the procreation of her own ancestors who will lead to her own birth a century later.

Trapped in limbo between her present and past, which determines her present and future, Dana emerges in her own time at the end of the novel alive, yet physically amputated. *Kindred's* time travel re-envisions the transmission of barbarism in official histories and archives by subverting embodied forms of experiential time.

Butler's novels disrupt the limitations of realist forms, genre, and history by attending to the materiality of flesh, engendering kindred resonances that are sustained by the magic found in the formless formation.

An inventive "renascence of a new corpus of sensibility,"[288] drives Butler's and Jemisin's novels, Brown's SOLHOT, and Ra's Arkestra, among countless others. These new awakenings are inseparable from the insights gleaned "from a state of cramp" and the myriad ways enclosures "articulate a new growth."[289] Harris emphasizes how the barbarism of structural colonialism and enslavement necessitates "a new kind of drama, novel and poem... a creative phenomenon of the first importance in the imagination of a people violated by economic fates."[290] Listen to the creative sounds issuing forth from these ongoing fates.

> Every day, everywhere, we hear the applied study and emanation of new kinds of mediums in a circulation of endless audio-inventories of style.

Just follow the sound.

Tracing the space/time and mind-bending trajectories of these sonic worlds, the Black Audio Film Collective's afro-futuristic film *The Last Angel of History* suggests that these particular sounds, heard in all forms of modern popular music, are inseparable from the experience of the Atlantic slave trade and its aftermath.[291] These historical catastrophes, which the film argues can be understood as ones of alien abduction and genetic mutation, are figured in the *Xenogenesis* series, as well as in *Kindred*'s wrestling with the sense of a "phantom limb."[292] The phantasmagorical sensation of

a missing part still felt present through its resonating absence is the limboing formlessness of imagination's aesthetic form.

> The enclosures of the wild wild west
> are always outpaced by imagination's contortions.

If the formlessness of form is both phantom limb and the act of being in limbo, then magic might be the residual effects of the fading presence of absence. This fading threshold, for instance, imbues the workings of magical realism, the making of amalgamation, an integration between the supernatural and the rational. In the film *Atlantique*,[293] the aesthetic-life-world of director Mati Diop raises the dead so as to come back to life by entering the bodies of the living in order to speak through them. The dead-alive are the Vodun spirits of a group of drowned migrants off the coast of Spain. They return to their West African shore to seek justice and revenge against the local capitalist elite responsible for their destitution and forced migration. Diop mobilizes magical realism as a method to keep love alive and to remember and honor those taken too soon from the realities of economic violation.

> Collapsing the hyperreal and the practical, magical realism
> disrupts the violence of representation.

Catastrophe always "seems to lead to a kind of magical realism" where moments of utter disaster reveal glimpses of "a kind of radiance on the other end of the maelstrom," notes Kamau Brathwaite.[294] In his poem "Meridian," the poetry collection *Ancestors*, and two-volume *MR (Magical Realism)*, Brathwaite refers to his archive of Caribbean radio broadcasts as "trance-missions."[295] These trance-missions are the intermingling waves between radio

transmissions, the poetic voice, and the sounds of trance-induc-
ing initiations of possession across Caribbean Afro-diasporic
religions. All of these trance-missions summon forth the poetic
neologism "ancestories."[296]

Ancestories and trance-missions tremor across the radio
signals of disparate histories resonating across contemporary
Caribbean quotidian life.

Ancestories fall from the metaphysical techne of many who work
against brutal semantics and maiming discourses. In magical real-
ism's power to transmit new breath, Brathwaite shapes the words:
"X pressions (indications) of literary cosmological disruption"[297]

And these X pressions of cosmological disruption vibrate across
Sun Ra's mythocracy, Brown's creative memory, Jemisin's quantum
breaks, Butler' xenogenesis and time travel, Diop's dead/alive
love — all ancestories surpassing the edge of fade into the material
possibilities of magic.[298]

RESPIRE

To respire is to turn the body over to aerating hapticality, a revelatory incident in formless formation where the respirational is atmospheric, mutational, symbiotic, all energy. Respiration is both a process and an exercise in breath, cropping up and coming to pass, taking shape, a communal befalling.

Calling forth an antiphonal *arkestration* open to love, not democratic care, respiration is a feeling that enlivens the collective the moment political debris evolves into a promising exodus. Necessarily breathed in unison, this respiration is an ideological imprint, a social composition on the ground (across magic) that contains the contours of all life, a shared exhalation for a movement piece in parts — soldiers of militant love in the wild wild west, fists up, airways open, listening to the sound.

The respirational recognize dispossession; they swarm the spectrum, refusing their own dialectic. Choreographing the flock, swarms move through their own suspension — a splitting movement that harbors the strands, the residue, the matter and meaning, all flight and fade.

Sentiments from the multiverse,
respirations carry the promise.

Breathing with the dead and the future in our acts of surviving
the present, respiration is an ancestral pilgrimage, every droplet of
air a continuum of culture. In this time travel of breath, how does
breath breathe in its temporal segments? When breath is both the
offering of new life and the possible evacuation of another, does
breath resist its own refusal?

For when one last droplet of air can be stolen by a savage *Other* from
an(other) human, the properties of respiration are no longer an
involuntary muscle movement, but a practice of combat.[299] Breath
is a discrepant engagement across passageways and afterlives,
for to respire is an opening for life and death and the exquisite
possibility of escape.

Studying the eternal quality of the middle passage, Sharpe stresses
how the "afterlives" of slavery still weather on.[300] To be in this
unsettled weather is to be at a distance from those who easily
assume a determined subject's place in the world. Moving across
literary, visual, cinematic, and quotidian expressions of Black life,
Sharpe methodologically produces what she names the "orthog-
raphy of the wake."[301] The "wake" and the other three terms that
make up the author's orthography — the "ship," the "hold," the
"weather" — discharge multidimensional turbulences of elemental
forms, forces, states, and trajectories. In forming this grammar,
the orthography of the "wake" attends to the term at once meta-
phorical but always-already material.

The watery waves trailing behind a ship's course, "the track left
on the water's surface by a ship; the disturbance caused by a body
swimming or moved, in water;" or "the air currents behind a body
in flight; a region of disturbed flow"[302] — this is Sharpe's assembly
of one meaning of the word wake. But as she powerfully notes,

meaning carries multiple ascendancies, for the wake is also a practice of watching over the dead, or "grief, celebration, memory, and those among the living who, through ritual mourn their passing and celebrate their life."[303] All meanings of the single term wake are what imbue the being of Blackness on the "wrong side of the Atlantic," but not only, for as she insists, one of the numerous manifestations of the wake is today's movement of people seeking refuge on another side of the Mediterranean. Being in the wake is at once a history and an ongoing presence of violence, death, and dispossession.

It is not enough to assume consciousness, but to do *wake work:* "a mode of inhabiting *and* rupturing this episteme with our own known lived and un/imaginable lives."[304] This un/imaginability in the name of labor is what Glissant calls "know[ing] ourselves as part and as crowd,"[305] a being-together that necessitates a fracturing of traditional modes of existence itself. In executing this performative labor, Sharpe confesses to be searching for "the form" of wake work.[306] How does she locate the structural properties of this un/imaginability? The form of wake work may be found in her analysis of respiring acts across the everyday, art, and poetry – in the very details of how she reads across aesthetic styles. In defending both the dead and those living "as carriers of terror"[307] through these forms of wake work, Sharpe opens up questions about the excess of modernity's determining "wake" within the break, and how life, art, and thought flee from the total climate of normative anti-Blackness.

Such breathing into writing as wake work is nothing less than the imperative of responsibility in face of the unspeakable, or the necessity of critical theoretical fictions as practice, as a "theoretical politics,"[308] as Nahum Dimitri Chandler insists. Chandler

re-poses the question posed to W.E.B. Du Bois, "How does it feel to be a problem?"[309] by turning to how being a problem in the wake, in collective breath, is to be a concerted problem for theory and thought itself.

Building on Du Bois's prescient 1903 statement that "the problem of the twentieth century is the problem of the color-line,"[310] Chandler offers the term "paraontology" so that this problem evolves into a site of possibility "that might address our common contemporary colonial and postcolonial nexus on a worldwide ensemble of horizons."[311]

Chandler considers how paraontological thinking enables a break from ontological distinctions that determine human hierarchies and orientations. Disrupting fixed categories, paraontology is concerned less with what is given and more with what is yet to *be* given, yet to come on a worldwide ensemble of horizons. The incessant overturning of the patterns of sedimented historical thought open up the chance for a future as an otherwise to the present.

For Chandler, Blackness is a paraontological status that escapes the historical constancies of racial ontology, and in its fugitivity, destroys fixed racial identities by affirming multiple existences. Chandler reads paraontology in excess to oppositional framings of identity/anti-identity, as a "vortex" built on "rhythmic turns."[312] The formless formation of paraontology as "the general possibility of the otherwise"[313] escapes its own terminology to resist the commodification of the term; in so doing, ongoing thought is cut off from fixed shores.

Breath before and in the wake is a paraontological respiration. In thinking back to Sharpe's words and now Chandler's invocation of

"the otherwise," we aspire through Ashon Crawley's philosophical treatise on the politics and aesthetics of breath.[314] For this author, the minor breathes in the arenas and interstices of shouting, whooping, glossolalia, noise-making, the deep inhalations of Black Pentecostalism. Turning to how these vocal expressions contribute to and reveal the necessary practices of thought-making, Crawley shuffles the core of epistemology and ontology to yield a new methodology for examining cultures under constant attack. Through diverse forms of aesthetic sociality that exceed the confines of modern thought, discourse, and the rules of communicability, Crawley finds political and spiritual meaning in the smallest unit of signification. And within all, there is a certain urgency to his reassessment of Black existence in his call for "otherwise worlds of possibility,"[315] or modes of existence that rattle and discompose the oppressive violence against minoritarian life.

From electrifying sounds to choral hums and screams, the sonically paraontological invokes its wake into the gaps between context and implication, for all these performative possibilities surface and work against racial subjugation and social marginalization.

So what might it mean to be in the wake of breath, to break breath in such waking work?

To break sonorous resonant breath is to delve into the realm of the paralinguistic (the entanglements of sound, gesture, tone, rhythm, texture, feeling) and how the study of paralanguage and paraontology undoes normative readings that define the "para" as solely auxiliary or derivative to a norm. Paralanguage's inexorable materiality, sensed as a swaying formless formation in its pre-condition for language, interrupts standardized approximations of discourse. To recognize paralanguage's capacity of sonic breath,

beat, and stroke is to disturb representational social patterns that generate rational subjectification.

Respired sounds make words different from one another; sense builds from nonsense. In "speaking in tongues," paralanguage fractures the structural powers that determine the sovereign by affirming non-exclusionary improvisations of collective breath. These expressive dissonances, like glossolalia for example, interrupt the hegemonic forces objectifying marginal life through the enterprise of communication. Paraontological paralanguage, therefore, opens up a space for resonating radical dispossession through the very refusal to re-state the state.

The denial of these accumulative norms is our formless formation in which language eclipses its own desire, verified in the details of sound, speech, and the written word.

Writing respectively and deliberately is also, for us, a kind of breathing within the wake, or a form of wake work embodying new rhizomatic, assembletic, and galactical affiliations between all entities. Breaking breath across these pages is an "otherwise world of possibility"[316] in which writing does not overdetermine one sound or one score.

Syntax is euphonic, melodic, and always relational, every syllable tempered by cadency, the flow of a breathing downbeat, the other. In concert with the symphonic and its dissension, these vignettes are a duo-ascendency, not a solo chirography. Despite structure, the singular voice is subordinated for an orchestration that pulsates in simultaneity.

A *respirit*, our manuscript enunciates in the inhale and reiterates through the exhale, an aspiration that listens for the loud gasp given to the end of this world, an elongated sigh collectively shaped, not in perfect unison but in consonance, not in closed harmony, but throughout the strain. For instance, we write into each other's manuscription at the sentence level, an "influx-and-efflux" for writing breath without sacrificing conviction.

The speech sound, the rhyme against the prose, and the song in the break of the cry resound in our script. The result is a tune, a discourse, a conversation, a number audible for the quorum, even when the negation of our roaring silence is still our song.

Writing, for Jane Bennett, is a process of "influx-and-efflux," a respiration to and fro that invokes the "ubiquitous tendency for outsides to come in, muddy the waters, and exit."[317] An expression taken from Whitman's "Song of Myself,"[318] "influx and efflux" concerns the quotidian movements that enable outside forces to occupy bodies, animate and rattle their singular composition, to then depart once such invigorating confusion is imposed. Every entity, in this process, is intimately reconstructed and constituted into something other.

Influx-and-efflux marks how writing's movements oscillate between porous extremities and radiating interiorities, both shifts recalibrate the self, the reader, the properties and subjects of citation, and the text's dynamic impulses happening across linguistic patterns. For Bennett, the conjoiner "and" is essential as it stresses how change bridges and flickers in-between the details of writing.

This is to write that influx-and-efflux is the constant doing and
undoing of the addition, or the magical entrances and exits
swarming across writing.

Bennett's evocation of influx-and-efflux attends to how writers
"ride the momentum of outside influences."[319] These momentums
charge through the written word as vibrant matter, for the vibrancy
of writing is inextricably linked to a plurality of resonances. Or,
influx-and-efflux marks the experience of being simultaneously
inside and outside the scene of writing, for the process of "writing
up" induces "a stutter, or lag, a delay before a vibratory *encounter*
becomes translated."[320] The influx and efflux of writing is "a sea
breathing itself in and out as waves."[321]

Like an otherwise arranged by syntactical reinvention, or the
influx-and-efflux of words across sentences, waves, and worlds,
writing is a sonic entanglement. It is a call and response beckoned
by ideological impulse, political determination, and social sound
that travels across disparate life forces. In writing, the bridges,
underpasses, and waking lines and ephemeral traces of this life
world embolden the connections between aesthetic styles. Through
an improvisational practice within constraint,[322] inspired by the
call to conspire (respire) together, writing is about who we read,
but also who we cite, engage, and refuse to summon.

Alice Coltrane claims that there are no coincidences, only inci-
dents.[323] This must include the breaking breath of writing too,
for the occurrence of resonance is another way to understand
the alchemy of synchronicity within the everyday. For instance,
imagine a dream one experiences that comes alive, or the face one
thinks about after many years and then locates in the flesh, how

did one know? Or the word one thinks at the same time another utters it? Is this not but the gift of magic, across breaking air that thrives against the crestfallen?

Resonance, especially in writing, is about a preexisting feeling already collectively felt before it was named.

Resonance is impossible to force, and yet the recognition of its evanescent occurrences enables the collapse of confining temporal and spatial accounts by way of reverberation's portals. Resonance's deviations pervade formless formations that collectivize in the nameless sound that's always coming.

Thriving both before and after the precepts of existence, all forms of life learn to flourish in the present known of an unknowable presence. While terrifying and lonesome, the unknowing that writing leaves open is a type of curious care, social love, a creative experimentation for friends across words. Such a flow of interested friendship is the encounter of relentless curiosity for one another. For in altering how to write-with, we inevitably alter one's interiority.

And in going in, we look out. In gazing forward, we collect the past. In all external aims, we labor to listen internally and eternally.

This is the praxis of writing, of friendship, a formless formation culled from the crevices of deep feeling and deep listening. Fred Moten understands the category of the unknowing as "the zone of nonbeing [as] experimental" or "a kind of experiment, this double edge of the experiment, this theater of like and unlike in which friendship's sociality overflows its political regulation."[324]

Friendship's sociality is a formless formation that overflows from within and without, a type of transformative living in fellowship.

If love at its essence is solidarity and "hope is as much a verb as it is a virtue,"[325] then the only way to survive and remake the earth is by way of an anti capitalist fellowship mounted by care, vulnerability, ethical compassion. From regions to cities and bodies to dust, new and magical social orders choreograph formless formations. To shout in an uprising is to "know ourselves as part and as crowd,"[326] planted in the tension between the unspeakable and the imperative to speak of fallen soldiers of love, to speak their names.

History's resolute pleasure is to unsound the windpipes of singular and plural life. The legacies of existence and the aesthetics of rebellions on occupied land, echo the unspeakable — every detail in its every discrepant engagement thunders against unbroken state suppression.

For liberation cannot be actualized by reforming social order into "a new law or constituent social body"[327] built from previous structures, but must be "measured by our capacity to destitute the governmental and economic mechanisms of labor, and of the capture of life more broadly."[328] More than an exercise in overthrowing power and rebuilding it from failed and fractured strands, the formless formation's ultimate abolition is made possible from the respiring spirit of fellowship and solidarity.

The affirmative negation of abolition includes the dissolution of capitalist relations as well as the self formed through these relations. This "activated negativity"[329] running through self-abolition is necessary to formless formations and powerfully grounded in material contexts and their overlapping differences. Formless

formations are not abstractions, for it is precisely the materiality of aesthetic-life-worlds that offer determinate formulas for correspondences across singular and collective respirations. In returning to Bataille, here, we recall that formlessness debases form through an operation of abolition as a vehicle for creativity on the ground.

Solidarity, therefore, is created by joining forms and then deforming them, leaving all institutions (*as we know them*) for dust, for these ashes are indicators of the evolution of wake work, of an otherwise possibility, fleeting and permanent, where to grieve the end of this *word* is to find the site and light of its new beginning.

Fists up. Wait for the sound.

> Break breath in these pages,
> for the open formless formation is
> the grit of syllable upon syllable,
> the influxes and effluxes of
> sounding sentences read and
> written together.

Listen for the cuts.

> Remake the score.

Endnotes

1 On March 28, 2019 at the Stedelijk Museum in Amster-
 dam, NL, and on behalf of the Studium Generale Riet-
 veld Academie 4-day conference *Take a Walk on the Wild
 Side: Fabulating Alternative Imaginaries in Art & Life*, which
 included days curated by Kunstverein, Daniela K.Rosner,
 and Tavia Nyong'o, we both took part in the conference
 day "Excess Swarm (Wild in the Wild)." On this day,
 Vourloumis invited scholars and artists to think alongside
 the idea of resonance as both a theory and practice of
 aesthetics and politics. Participants of the event included
 Nwando Ebizie, Gayatri Gopinath, Malak Helmy & Janine
 Armin, Rukeya (Monsur) Mansoor, Amber Musser, Jackie
 Wang and Sandra Ruiz (event description here: https://
 www.stedelijk.nl/en/events/hypatia-vourloumis).The
 event's opening remarks can be found here (https://www.
 youtube.com/watch?v=gQvcGVhJ334). We thank Jorinde
 Seijdel for inviting us to participate and share our work
 with each other. After this conference day, in the momen-
 tum of a shared resonance, we joined energies and ideas,
 and collaborated on co-authoring this book. Sophie
 Muller dir., *Soldier of Love*, perf. Sade, RCA Records, New
 York, NY, 2010.

2 Sade, "Soldier of Love," *Soldier of Love*, RCA Records, 2010.

3 Sade, "Soldier of Love."

4 Wu Tsang dir., *Wildness*, Class Productions, 2012.

5 "Michio Kaku: The Universe Is a Symphony of Vibrat-
 ing Strings," *Big Think*, May 31, 2011, https://youtu.be/
 fW6JFKgbAF4

6 "Michio Kaku: The Multiverse Has 11 Dimensions," *Big Think*, May 31, 2011, https://youtu.be/jI5oHNoKshg

7 Nathaniel Mackey, *Discrepant Engagement: Dissonance, Cross-Culturality, and Experimental Writing* (Cambridge: Cambridge University Press, 1993), 180.

8 Mackey, *Discrepant Engagement*, 3.

9 Mackey, *Discrepant Engagement*, 19.

10 Dawn Ades and Fiona Bradley, "Introduction," in *Undercover Surrealism: Georges Bataille and* DOCUMENTS, eds. Ades, Bradley, and Baker (Cambridge, MA: MIT Press, 2006), 11.

11 Yve-Alain Bois, "The Use Value of the 'Formless'," in *Formless: A User's Guide*, eds. Bois and Kraus (New York, NY: Zone Books, 1997), 18.

12 Georges Bataille, "Architecture," *Documents* 1, no. 2 (1929): 117; Reprint in *Oeuvres Completes* Vol. 1, trans. Dominic Faccini (Paris: Gallimard, 1970), 172.

13 Bataille, *Documents* 1, no. 7 (1929): 382; *Oeuvres Completes* Vol. 1, 80.

14 Bataille, "Formless," *Documents* 1, (1929): 382; Reprint in *Vision of Excess: Selected Writings, 1927-1939*, trans. Allan Stoekl, Carl R. Lovitt, and Donald M. Leslie Jr. (Minneapolis, MN: University of Minnesota Press, 1985), 31.

15 Bataille, "Formless," 382; *Vision of Excess*, 31.

16 "From Cooperation to Black Operation: A Conversation with Stefano Harney and Fred Moten on *The Undercommons*," *Transversal Texts*, April 2016, https://transversal.at/

blog/From-cooperation-to-black-operation.

17 "From Cooperation to Black Operation."

18 "From Cooperation to Black Operation."

19 "From Cooperation to Black Operation."

20 The Invisible Committee, *Now,* trans. Robert Hurley
 (Cambridge, MA: MIT Press, 2017), 70.

21 The Invisible Committee, *The Coming Insurrection* (Cam-
 bridge, MA: MIT Press, 2007), 12.

22 The Invisible Committee, *Now,* 42.

23 Denise Ferreira da Silva, "On Difference Without Separa-
 bility," *32nd Bienal De São Paulo Art Biennial: Incerteza viva,*
 2016, 57-65.

24 Ferreira da Silva, "On Difference Without Separability,"
 64.

25 Ferreira da Silva, "On Difference Without Separability,"
 64.

26 Ferreira da Silva, "On Difference Without Separability,"
 65.

27 R.E.M., "It's the End of the World as We Know It (And I
 Feel Fine)," *Document,* I.R.S., 1987.

28 Cedric Robinson, *The Terms of Order: Political Science and
 the Myth of Leadership* (Durham, NC: University of North
 Carolina Press, 2016).

29 Thomas Sankara, "A United Front Against Debt," *View-
 point,* February 1, 2018, https://www.viewpointmag.

com/2018/02/01/united-front-debt-1987/

30 The Invisible Committee, *The Coming Insurrection*, 12.

31 Raymond Williams, *Keywords: A Vocabulary of Culture and Society* (Oxford: Oxford University Press, 2014 [1976]).

32 bell hooks, "An Aesthetic of Blackness: Strange and Oppositional," *Lenox Avenue: A Journal of Interarts Inquiry*, Vol. 1 (1995 [1990]), 65.

33 We want to thank Uri McMillan and Shane Vogel for their theoretical framings and renderings of a minoritarian aesthetic, both in their individual work and as series editors of Minoritarian Aesthetics at NYU Press.

34 The Invisible Committee, *The Coming Insurrection*, 12.

35 The Invisible Committee, *The Coming Insurrection*, 12-13.

36 Ralph Ellison, *Invisible Man* (New York, NY: Random House, 1952), xxiii.

37 Stevphen Shukaitis, *The Compositions of Movements to Come: Aesthetics and Cultural Labor after the Avant-Garde* (Lanham, MD: Rowman & Littlefield, 2015), ix.

38 Shukaitis, *The Compositions of Movements to Come*, ix.

39 Shukaitis, *The Compositions of Movements to Come*.

40 Randy Martin, *The Politics of Preemption*, Greg Elmer dir., *Art & Education*, October 2019, https://www.artandeducation.net/classroom/video/294555/randy-martin-the-politics-of-preemption

41 Kamau Brathwaite, *ConVERSations with Nathaniel Mackey* (New York: We Press, 1999), 34.

42 Félix Guattari, "Machine et Structure," in *Psychanalyse et transversalité: Essais d'analyse institutionelle* (Paris: La Découverte, 2003), 247.

43 Hypatia Vourloumis, "Ten Theses on Touch, or, Writing Touch," *Women & Performance*, February 2, 2015, https://www.womenandperformance.org/ampersand/ampersand-articles/ten-theses-on-touch-or-writing-touch-hypatia-vourloumis.html

44 Adrienne Maree Brown, *Emergent Strategies* (Chico, CA: AK Press, 2017).

45 Jo Freeman, "The Tyranny of Structurelessness," *Struggle*, 2000 (1970), http://struggle.ws/pdfs/tyranny.pdf

46 Referring to the Sun Ra Arkestra

47 Vijay Iyer, "Exploding the Narrative in Jazz Improvisation," in *Uptown Conversation: The New Jazz Studies*, eds. Robert G. O'Meally, Brent Hayes Edwards, and Farah Jasmine Griffin (New York, NY: Columbia University Press, 2004). 393-403.

48 Iyer, "Exploding the Narrative," 394.

49 Iyer, "Exploding the Narrative," 394.

50 Iyer, "Exploding the Narrative," 395.

51 Iyer, "Exploding the Narrative," 395.

52 Iyer, "Exploding the Narrative," 395.

53 Iyer "Exploding the Narrative," 396.

54 Iyer "Exploding the Narrative," 398.

55 Iyer "Exploding the Narrative," 399.

56 Iyer, "Exploding the Narrative," 395.

57 Iyer "Exploding the Narrative," 399.

58 Iyer "Exploding the Narrative," 395.

59 Iyer "Exploding the Narrative," 395.

60 boychild, Josh Johnson, and Total Freedom, *Untitled Duet (the storm called progress)*, Gropius Bau, Berlin, February 1-2, 2020.

61 boychild, interviewed by the author, Hypatia Vourloumis, May 4, 2020.

62 Walter Benjamin, "Theses on the Philosophy of History," in *Illuminations: Essays and Reflections*, trans. Harry Zohn (New York, NY: Schocken Books, 1969), 13.

63 boychild, interviewed by the author, Hypatia Vourloumis, May 4, 2020.

64 José Esteban Muñoz, "Vitalism's After-Burn: The Sense of Ana Mendieta," *Women & Performance: A Journal of Feminist Theory* 21:2 (July 2011), 191-198.

65 Muñoz, "Vitalism's After-Burn," 197.

66 Muñoz, "Vitalism's After-Burn," 197.

67 Muñoz, "Vitalism's After-Burn," 197.

68 Sandra Ruiz, *Ricanness: Enduring Time in Anticolonial Performance* (New York, NY: NYU Press, 2019), 136.

69 José Esteban Muñoz, "'Chico, what does it feel like to be a problem?': The Transmission of Brownness," in

A Companion to Latina/o Studies, eds. Juan Flores and Renato Rosaldo (Malden, MA: Blackwell Publishing, 2007), 441-451.

70 Gayatri Gopinath, *Unruly Visions: The Aesthetic Practices of Queer Diaspora*, (Durham, NC: Duke University Press, 2018).

71 Gopinath, *Unruly Visions*, 4.

72 Gopinath, *Unruly Visions*, 5.

73 Ronak K. Kapadia, *Insurgent Aesthetics: Security and the Queer Life of the Forever War* (Durham, NC: Duke University Press, 2019), 2.

74 Kapadia, *Insurgent Aesthetics*, 3.

75 Kapadia, *Insurgent Aesthetics*, 30.

76 Kapadia, *Insurgent Aesthetics*, 30.

77 Muñoz, "'Chico, what does it feel like to be a problem?'" 441-451.

78 Alexandra T. Vazquez, *Listening in Detail: Performances of Cuban Music* (Durham, NC: Duke University Press, 2013), 20.

79 Vazquez, *Listening in Detail*, 8.

80 Vijay Iyer, "Exploding the Narrative in Jazz Improvisation," in *Uptown Conversation: The New Jazz Studies*, eds. Robert G. O'Meally, Brent Hayes Edwards, and Farah Jasmine Griffin (New York, NY: Columbia University Press, 2004). 393-403.

81 Julia Steinmetz, "In Recognition of Their Desperation:

Sonic Relationality and the Work of Deep Listening,"
Studies in Gender and Sexuality, 20:2 (2019), 119-120.

82 Steinmetz, "In Recognition of Their Desperation."

83 Steinmetz, "In Recognition of Their Desperation," 120.

84 Roland Barthes, *Camera Lucida: Reflections on Photography*,
trans. Richard Howard (New York, NY: Farrar, Straus, and
Giroux, 1981).

85 Steinmetz, "In Recognition of Their Desperation," 130.

86 Steinmetz, "In Recognition of Their Desperation," 119.

87 "Pauline Oliveros: Still Listening!" *Deep Listening Institute*,
https://www.deeplistening.org

88 Steinmetz, "In Recognition of Their Desperation," 119-132.

89 Erica Gressman, qtd. in S.G. Maldonado-Vélez, "Erica
Gressman," *La Estación Gallery Podcast*, November 8, 2019,
https://soundcloud.com/user-605923905/erica-gressman

90 Erica Gressman, *COVID-19*, The Quarantine Concerts,
Experimental Sound Studio, Chicago, IL, April 1, 2020,
https://www.youtube.com/watch?v=FsyFD-xjeRo&t=5s
Gressman, interviewed by author, Sandra Ruiz, April 2,
2020.

91 Fiona Ngô, in conversation with Joshua Chambers-Let-
son and Sandra Ruiz, following Erica Gressman's *Limbs*,
Krannert Art Museum, Champagne, IL, September 13,
2018. Curated by Sandra Ruiz with the help of Amy Powell,
KAM staff, and *La Estación* Gallery interns and Latina/
Latino Studies staff: https://kam.illinois.edu/event/eri-
ca-gressman-limbs

92 Erica Gressman, *Wall of Skin*, Channing Murray Foundation, Urbana, IL, April 7, 2016.

93 Julia Steinmetz, "In Recognition of Their Desperation," 119-132.

94 Ligia Lewis, Jonathan Gonzalez, Hector Thami Manekehla, and Tiran Willemse, *minor matter*, HAU Hebbel am Ufer, Berlin, November 24-27, 2016. Thank you to Joshua Chambers-Letson for sharing his research materials and for placing us in direct contact with Ligia Lewis.

95 Remi Raji, "Dreamtalk," *Gather My Blood Rivers of Song* (Ibadan: Diktaris, 2009).

96 Lewis, Gonzalez, Manekehla, and Willemse, *minor matter*.

97 Donna Summer, "I Feel Love," *I Remember Yesterday*, Casablanca, 1977.

98 Lewis, Gonzalez, Manekehla, and Willemse, *minor matter*.

99 Lewis, Gonzalez, Manekehla, and Willemse, *minor matter*.

100 Anh Vo "On Blackness – Ligia Lewis: Minor Matter (2016)," *Cult Plastic: Dance and Culture in the Plastic Age*, June 26, 2017, https://cultplastic.com/2017/06/26/on-blackness-ligia-lewis-minor-matter-2016/

101 Lewis, Gonzalez, Manekehla, and Willemse, *minor matter*.

102 Lewis, Gonzalez, Manekehla, and Willemse, *minor matter*.

103 Lewis, Gonzalez, Manekehla, and Willemse, *minor matter*.

104 Lewis, Gonzalez, Manekehla, and Willemse, *minor matter*.

105 Hartmut Rosa, *Resonance: A Sociology of Our Relationship to*

the World, trans. J. Wagner (Cambridge, MA: Polity, 2019 [2016]), 282.

106 Rosa, *Resonance*, 761.

107 Simon Susen, "The Resonance of Resonance: Critical Theory as a Sociology of World-Relations?" *International Journal of Politics, Culture, and Society* 33 (2020): 309-344.

108 Susen, "The Resonance of Resonance," 309-344.

109 For new work on Sun Ra and interstellar dust and matter see Jayna Brown's forthcoming book *Black Utopias: Speculative Life and the Music of Other Worlds* (Duke University Press). Also see Jayna Brown's talk *A Fierce Organicism: Ecologies of Enmeshment in Contemporary Speculative Art* here: https://youtu.be/u8MXDEOZL8E

110 Sun Ra, qtd. in Robert Mugge dir., *Sun Ra: A Joyful Noise*, 1980.

111 Sun Ra Arkestra, "Nuclear War," Y Records, 1982.

112 Sun Ra, "We Hold This Myth To Be Potential (1980)" in *The Immeasurable Equation: The Collected Poetry and Prose*, eds. James L. Wolf and Hartmut Geerken (Wartaweil, Germany: WAITAWHILE, 2005), 420.

113 Wilson Harris, "The Unfinished Genesis of the Imagination," *The Journal of Commonwealth Literature* 27:1 (March 1, 1992), 13-25.

114 *Moved by the Motion*, *Sudden Rise*, Whitney Museum of American Art, New York, NY, April 26-27, 2019.

115 Wu Tsang and Fred Moten, "Sudden Rise at a Given Tune," *South Atlantic Quarterly* 117:3 (2018), 649-652.

116 W.E.B. Du Bois, "Sociology Hesitant," *boundary 2* 27:3 (Fall 2000), 37-44.

117 Wu Tsang, dir., *We hold where study*, The Modern Women's Fund, MoMA, New York, NY, ongoing 2017.

118 Wu Tsang, dir., *One emerging from a point of view*, Sharjah Art Foundation and Onassis Fast Forward Festival 6, Athens, Greece, May 5-19, 2019.

119 Édouard Glissant, *Poetics of Relation*, trans. Betsy Wing (Ann Arbor, MI: University of Michigan Press, 1997).

120 Glissant, *Poetics of Relation*, xiii.

121 Wu Tsang, "There Is No Non-Violent Way to Look at Somebody," Gropius Bau, Berlin, September 4, 2019 - January 12, 2020.

122 Wu Tsang and Fred Moten, "Sudden Rise at a Given Tune," *South Atlantic Quarterly* 117, no. 3 (2018): 649-652. See also W.E.B. Du Bois, "Sociology Hesitant," *boundary 2* 27, no. 3 (Fall 2000): 37-44.

123 Las Tesis, "Un Violador En Tu Camino," performed on International Day for the Elimination of Violence Against Women in Santiago, Chile, November 25, 2019.

124 For more on this uprising see, https://suarapapua.com/2020/06/12/the-voice-of-papua-news-letter-papuan-lives-matter/

125 Glissant, *Poetics of Relation*.

126 Simeon Man, A. Naomi Paik, and Melina Pappademos, "Violent Entanglements: Militarism and Capitalism," *Radical History Review* 133 (January 2019), 1.

127 Michel Foucault, *Discipline and Punish: The Birth of the Prison*, trans. Alan Sheridan (New York, NY: Knopf Doubleday, 2012 [1975]), 135.

128 Foucault, *Discipline and Punish*, 170.

129 José Esteban Muñoz, *Disidentifications: Queers of Color and the Performance of Politics*, (Minneapolis, MN: University of Minnesota Press, 1999), 182.

130 Patricia Nguyen, with Jim Ludes and G. Wayne Miller, *Story in the Public Square: Season 3*, The Pell Center, Newport, RI, October 21, 2019, https://www.youtube.com/watch?v=QGpGb67mfto

131 Patricia Nguyen, "Building a Monumental Anti-Monument: The Chicago Torture Justice Memorial," *The Funambulist*, 2019, https://thefunambulist.net/articles/building-a-monumental%E2%80%A8anti-monument-the-chicago-torture-justice-memorial-by-patricia-nguyen

132 Patricia Nguyen, "Statement," *The Funambulist*, 2019, 46.

133 Nguyen, "Building a Monumental Anti-Monument," 51.

134 Nguyen, "Building a Monumental Anti-Monument," 50.

135 Nguyen, with Jim Ludes and G. Wayne Miller, *Story in the Public Square: Season 3*, The Pell Center, Newport, RI, October 21, 2019, https://www.youtube.com/watch?v=QGpGb67mfto

136 Patricia Nguyen, *Untitled*, in *Groundlings*, Museum of Contemporary Art, Chicago, IL, March 2019; Patricia Nguyen, *Echoes*, in *Upheavals*, Defibrillator Gallery + Zhou B Art

Center, Chicago, IL, September 2019.

137 "Fred Moten with Jarrett Earnest," *The Brooklyn Rail: Critical Perspectives on Art, Politics, and Culture*, November 2017, https://brooklynrail.org/2017/11/art/FRED-MOTEN-with-Jarrett-Earnest

138 "Fred Moten with Jarrett Earnest."

139 "Fred Moten with Jarrett Earnest."

140 "Fred Moten with Jarrett Earnest."

141 Brent Hayes Edwards, *Epistrophies: Jazz and the Literary Imagination* (Cambridge, MA: Harvard University Press, 2017), 47.

142 Edwards, *Epistrophies*, 47.

143 Aimé Césaire, Joan Pinkham, and Robin D.G. Kelley, *Discourse on Colonialism* (New York, NY: NYU Press, 2000), 42.

144 Césaire, Pinkham, and Kelley, *Discourse on Colonialism*, 43.

145 Robin D.G. Kelley, "A Poetics of Anticolonialism," in Césaire, Pinkham, and Kelley, *Discourse on Colonialism* (New York, NY: NYU Press, 2000), 25.

146 Kelley, "A Poetics of Anticolonialism," 25.

147 Kelley, "A Poetics of Anticolonialism," 26.

148 Jeff Conant, "What the Zapatistas Can Teach Us About the Climate Crisis," *Foreign Policy in Focus*, August 3, 2010, https://fpif.org/what__the__zapatistas__can__teach__us__about__the__climate__crisis/

149 Manuel Callahan, "In Defense of Conviviality and the Collective Subject," *Polis Revista Latinoamericana* 33 (2012), https://journals.openedition.org/polis/8432

150 Conant, "What the Zapatistas Can Teach Us."

151 Conant, "What the Zapatistas Can Teach Us."

152 Conant, "What the Zapatistas Can Teach Us."

153 Fred Moten, *Black and Blur* (Durham, NC: Duke University Press, 2017), vii; *The Universal Machine* (Durham, NC: Duke University Press, 2018), 112.

154 Eve Tuck and K. Wayne Yang, "Decolonization Is Not a Metaphor," *Decolonization: Indigeneity, Education & Society*, 1, on. 1 (2012): 1.

155 Tuck and Yang, "Decolonization Is Not a Metaphor," 4.

156 "Rethinking the Apocalypse: An Indigenous Anti-Futurist Manifesto," *Indigenous Action*, March 19, 2020, http://www.indigenousaction.org/rethinking-the-apocalypse-an-indigenous-anti-futurist-manifesto/

157 "Rethinking the Apocalypse: An Indigenous Anti-Futurist Manifesto."

158 Audra Simpson, *Mohawk Interruptus: Political Life Across the Borders of Settler States* (Durham, NC: Duke University Press, 2014).

159 "Rethinking the Apocalypse: An Indigenous Anti-Futurist Manifesto."

160 Ned Rossiter and Soenke Zehle, "Acts of Translation: Organizing Networks as Algorithmic Technologies of the

Common," *NedRossiter.org*, April 27, 2013, https://nedrossiter.org/?p=332

161 Frederick Jameson, *Postmodernism, Or, the Cultural Logic of Late Capitalism* (Durham, NC: Duke University Press, 1991), 409.

162 Jameson, *Postmodernism.*

163 Rita Indiana qtd. in Wilda Escarfuller, "[i]AQ[/i] Interview: Rita Indiana Captivates Merengue Fans in New York City," *Americas Quarterly*, July 10, 2011, https://www.americasquarterly.org/article/iaq-i-interview-rita-indiana-captivates-merengue-fans-in-new-york-city/

164 Rita Indiana qtd. in Escarfuller, "[i]AQ[/i] Interview: Rita Indiana Captivates."

165 Engel Leonardo, dir., *Da Pa Lo Do*, perf. Rita Indiana y Los Misterios, Premium Latin Music, 2010, https://www.youtube.com/watch?v=Y72XAybPTnU

166 For more detailed work on Rita Indiana and theories of Dominicanness please see "Da pa' lo' do' ": Rita Indiana's Queer, Racialized Dominicanness" by Karen Jaime in *Small Axe* 19(2), 2015: 85-93.

167 Noelia Quintero, dir., *La Hora de Volve*, perf. Rita Indiana y Los Misterios, Premium Latin Music, 2010.

168 Rita Indiana y Los Misterios "La Hora de Volve," *El Juidero*, Premium Latin Music, 2010.

169 Rita Indiana y Los Misterios "La Hora de Volve."

170 Rita Indiana y Los Misterios "La Hora de Volve."

171 Rita Indiana qtd. in Escarfuller, "[i]AQ[/i] Interview: Rita Indiana Captivates."

172 Eve Kosovsky Sedgwick, *Tendencies* (Durham, NC: Duke University Press, 1993), 8.

173 Vaginal Davis, N-Prolenta, ¥€$Si PERSE, and Urami, *Cherish x Queer Is Not A Label*, Route de Saint-George 51, Geneva, Switzerland, March 13-14, 2020.

174 Brent Hayes Edwards, *Epistrophies: Jazz and the Literary Imagination* (Cambridge, MA: Harvard University Press, 2017), 10.

175 Edwards, *Epistrophies*.

176 Sara Ahmed, *What's the Use? On the Uses of Use* (Durham, NC: Duke University Press, 2019).

177 Ahmed, *What's the Use?* 203.

178 Ahmed, *What's the Use?* 208.

179 Ahmed, *What's the Use?* 207.

180 Ahmed, *What's the Use?* 198.

181 Ahmed, *What's the Use?* 207.

182 "Rethinking the Apocalypse: An Indigenous Anti-Futurist Manifesto," *Indigenous Action*, March 19, 2020, http://www.indigenousaction.org/rethinking-the-apocalypse-an-indigenous-anti-futurist-manifesto/

183 Ahmed, *What's the Use?* 207.

184 Ahmed, *What's the Use?* 208.

185 Ahmed, *What's the Use?* 208.

186 Ahmed, *What's the Use?* 208.

187 Ahmed, *What's the Use?* 208.

188 Nick Mirzoeff, "Boggs Standard Time – in Detroit and Beyond," *Waging Nonviolence*, January 27, 2014, https://wagingnonviolence.org/2014/01/boggs-standard-time-detroit-beyond/

189 Mirzoeff, "Boggs Standard Time – in Detroit and Beyond."

190 Fred Moten and Stefano Harney, *The Undercommons: Fugitive Planning & Black Study* (Chico, CA: AK Press, 2013).

191 Sylvia Wynter qtd. in David Scott, "The re-enchantment of humanism: An interview with Sylvia Wynter," *Small Axe: A Caribbean Journal of Criticism*, 4:2 (2000), 123.

192 Sylvia Wynter, "Unsettling the Coloniality of Being/Power/Truth/Freedom: Towards the Human, After Man, Its Overrepresentation – An Argument," *CR: The New Centennial Review*, 3:3 (fall 2003), 260-261.

193 Sylvia Wynter and Katherine McKittrick, "Unparalleled Catastrophe for Our Species? Or, to Give Humanness a Different Future: Conversations," in *Sylvia Wynter: On Being Human as Praxis*, ed. Katherine McKittrick (Durham, NC: Duke University Press, 2015), 23.

194 Sylvia Wynter, "The Pope Must Have Been Drunk, the King of Castile a Madmen: Culture as Actually and the Caribbean Rethinking of Modernity," in *Reordering of Culture: Latin America, the Caribbean and Canada in the 'Hood*, eds. A. Ruprecht and C. Taiana (Ottawa: Carleton University Press, 1995), 35.

195 Katherine McKittrick, "Axis, Bold as Love," in *Sylvia Wynter: On Being Human as Praxis* (Durham, NC: Duke University Press, 2015), 160.

196 McKittrick, "Axis, Bold as Love," 160.

197 McKittrick, "Axis, Bold as Love," 160.

198 McKittrick, "Axis, Bold as Love," 160.

199 Karl Marx, *Capital: A Critique of Political Economy Vol. 1*, ed. Frederick Engels, trans. Samuel Moore and Edward Aveling (Moscow: Progress Publishers, 1887), 48.

200 Marx, *Capital*, 107.

201 Wynter, "Unsettling the Coloniality," 331.

202 Sandra Ruiz, *Ricanness: Enduring Time in Anticolonial Performance* (New York, NY: NYU Press, 2019), 3.

203 Ann Laura Stoler, *Imperial Debris: On Ruins and Ruination* (Durham, NC: Duke University Press, 2013).

204 Sun Ra, qtd. in Robert Mugge dir., *Sun Ra: A Joyful Noise*, 1980.

205 Sun Ra, qtd. in Robert Mugge dir., *Sun Ra: A Joyful Noise*, 1980.

206 Sun Ra, "we must not say no to ourselves," in *The Planet is Doomed* (New York, NY: Kicks Books, 2011), 47.

207 Ra, "we must not say no to ourselves," 47.

208 Youmna Chlala, *The Paper Camera* (Brooklyn, NY: Litmus Press, 2019), 5.

209 Ghassan Moussawi, *Disruptive Situations: Fractal Oriental-*

ism and Queer Strategies in Beirut (Philadelphia, PA: Temple University Press, 2020).

210 Youmna Chlala, "[To imagine]," in *The Paper Camera* (Brooklyn, NY: Litmus Press, 2019), 11.

211 Youmna Chlala, "[In a constant state]," in *The Paper Camera* (Brooklyn, NY: Litmus Press, 2019), 77.

212 José Esteban Muñoz, "Ephemera as Evidence: Introductory Notes to Queer Acts," *Women & Performance: A Journal of Feminist Theory* 8:2 (1996), 5-16.

213 Muñoz, "Ephemera as Evidence," 10-11.

214 David Harvey, "Marx's Refusal of the Labour Theory of Value," *Reading Marx's Capital with David Harvey*, March 14, 2018, http://davidharvey.org/2018/03/marxs-refusal-of-the-labour-theory-of-value-by-david-harvey/

215 Wynter, "The Pope Must Have Been Drunk," 35.

216 Wynter, "Unsettling the Coloniality," 331.

217 Jane Bennett, *Influx & Efflux: Writing Up with Walt Whitman* (Durham, NC: Duke University Press, 2020).

218 Karen Barad, "Diffracting Diffraction: Cutting Together-Apart," *Parallax* 20:3 (2014), 168-187.

219 Roland Barthes, *Camera Lucida: Reflections on Photography*, trans. Richard Howard (New York, NY: Farrar, Straus, and Giroux, 1981), 25-26.

220 Barthes, *Camera Lucida*, 55.

221 Barthes, *Camera Lucida*, 59.

222 Barthes, *Camera Lucida*, 59.

223 Barthes, *Camera Lucida*, 73.

224 Barthes, *Camera Lucida*, 38.

225 Barthes, *Camera Lucida*, 59.

226 Gayatri Chakravorty Spivak in Steve Paulson, "Critical
 Intimacy: An Interview with Gayatri Chakravorty Spi-
 vak," *Los Angeles Review of Books*, July 29, 2016, https://
 lareviewofbooks.org/article/critical-intimacy-inter-
 view-gayatri-chakravorty-spivak/

227 Jacques Derrida, "Différance," in *Margins of Philosophy*,
 trans. Alan Bass (Chicago, IL: University of Chicago Press,
 1982), 3-27.

228 Jacques Derrida, *Positions*, trans. Alan Bass (Chicago, IL:
 University of Chicago Press, 1981), 27.

229 Derrida, *Positions*, 27.

230 "Jacques Derrida – On Being," in *Derrida*, dirs. Kirby Dick
 and Amy Ziering, Jane Doe Films, 2002, https://www.
 youtube.com/watch?v=gjmpoZAz5yk

231 Jacques Derrida, *Speech and Phenomena, And Other Essays
 on Husserl's Theory of Signs*, trans. David B. Allison (Evan-
 ston, IL: Northwestern University Press, 1973), 156.

232 Derrida, *Speech and Phenomena*, 156.

233 "Jacques Derrida – On Being."

234 Geoffrey Bennington, "Embarassing Ourselves," *Los Ange-
 les Review of Books*, March 20, 2016, https://lareviewof-
 books.org/article/embarrassing-ourselves/

235 Ocean Vuong, *On Earth We're Briefly Gorgeous* (New York, NY: Penguin Press, 2019), 8.

236 Vuong, *On Earth We're Briefly Gorgeous*, 9.

237 Jane Bennett, Influx & Efflux: Writing Up with Walt Whitman (Durham, NC: Duke University Press, 2020).

238 Vuong, *On Earth We're Briefly Gorgeous*, 10.

239 Vuong, *On Earth We're Briefly Gorgeous*, 10.

240 Vuong, *On Earth We're Briefly Gorgeous*, 75.

241 Vuong, *On Earth We're Briefly Gorgeous*, 85.

242 Laura Harris, *Experiments in Exile: C. L. R. James, Hélio Oiticica, and the Aesthetic Sociality of Blackness* (New York, NY: Fordham University Press, 2018), p.10-11.

243 Harris, *Experiments in Exile*, 2-8.

244 Peter Linebaugh and Marcus Rediker, *The Many-Headed Hydra: Sailors, Slaves, Commoners, and the Hidden History of the Revolutionary Atlantic* (New York, NY: Verso Books, 2012), 332.

245 Vijay Iyer, "Exploding the Narrative in Jazz Improvisation," *Uptown Conversation: The New Jazz Studies*, eds. Robert G. O'Meally, Brent Hayes Edwards, and Farah Jasmine Griffin (New York, NY: Columbia University Press, 2004), 395.

246 Laura Harris, "What Happened to the Motley Crew: C.L.R. James, Hélio Oiticica, and the Aesthetic Sociality of Blackness?" in *Experiments in Exile: C. L. R. James, Hélio Oiticica, and the Aesthetic Sociality of Blackness* (New York,

NY: Fordham University Press, 2018), 33.

247 Harris, "What Happened to the Motley Crew," in *Experiments in Exile*, 33.

248 Fred Moten, *In the Break: The Aesthetics of the Black Radical Tradition* (Minneapolis, MN: University of Minnesota Press, 2003), 22.

249 Vuong, *On Earth We're Briefly Gorgeous*, 8.

250 Frantz Fanon, *The Wretched of the Earth*, trans. Richard Philcox (New York, NY: Grove Atlantic, 2007 [1961]).

251 Sylvia Rivera, "Y'all Better Quiet Down," Christopher Street Liberation Day rally, Washington Square Park, New York, NY 1973.

252 Rivera, "Y'all Better Quiet Down."

253 Rivera, "Y'all Better Quiet Down."

254 Rivera, "Y'all Better Quiet Down."

255 Rivera, "Y'all Better Quiet Down."

256 Combahee River Collective Statement, April 1977, http://circuitous.org/scraps/combahee.html

257 Césaire, Pinkham, and Kelley, *Discourse on Colonialism*, 137.

258 Walter Benjamin, *The Arcades Project*, third edition, trans. Howard Eiland and Kevin McLaughlin (Cambridge, MA: Harvard University Press, 2002 [1982]).

259 Ruth Nicole Brown, *Hear Our Truths: The Creative Potential of Black Girlhood* (Champaign, IL: University of Illinois Press, 2013), 1.

260 Moten, *In the Break*, 22.

261 Brown, *Hear Our Truths*, 31.

262 Brown, *Hear Our Truths*, 2.

263 Sun Ra, qtd. in *Sun Ra: A Joyful Noise*, dir. Robert Mugge, 1980.

264 Graham Lock, *Blutopia: Visions of the Future and Revisions of the Past in the Work of Sun Ra, Duke Ellington, and Anthony Braxton* (Durham, NC: Duke University Press, 1999).

265 Lock, *Blutopia*, 14.

266 Ra, qtd. in *Sun Ra: A Joyful Noise*.

267 Sun Ra, "man and planet earth," in *The Planet Is Doomed* (New York, NY: Kicks Books, 2011), 95.

268 Lock, *Blutopia*, 74.

269 Sun Ra, "infinity is the language," in *The Planet Is Doomed* (New York, NY: Kicks Books, 2011), 73.

270 Ra, qtd. in *Sun Ra: A Joyful Noise*.

271 "Manos Danezis with George Sachinis," *Antithesis*, CreteTV, May 13, 2017, https://www.youtube.com/watch?v=yzvFTPM21bs&t=196s

272 Alexis Lothian, *Old Futures: Speculative Fiction and Queer Possibility* (New York, NY: NYU Press, 2018).

273 Lothian, *Old Futures*.

274 Lothian, *Old Futures*, 17.

275 William Gibson, "Books of the Year," *The Economist*,

December 4, 2003.

276 N.K. Jemisin, *The Fifth Season* (London: Orbit, 2015).

277 Jemisin, Appendix 2, Glossary: "Orogeny," in *The Fifth Season*, 462.

278 Jemisin, *The Fifth Season*, 166.

279 Octavia E. Butler, *Dawn* (New York, NY: Grand Central Publishing, 1997).

280 Kodwo Eshun, "Feminism: Possibilities for Knowing, Doing, and Existing. A Conversation Between the Otolith Group and Annie Fletcher," *L'Internationale Online*, June 24, 2018, https://www.internationaleonline.org/research/politics__of__life__and__death/107__feminism__possibilities__for__knowing__doing__and__existing__a__conversation__between__the__otolith__group__and__annie__fletcher/

281 Octavia E. Butler, *Parable of the Sower* (New York, NY: Grand Central Publishing, 1993), 195.

282 Eshun, "Feminism: Possibilities for Knowing."

283 Adrienne Maree Brown, *Emergent Strategies* (Chico, CA: AK Press, 2017).

284 Walter Benjamin, "Theses on the Philosophy of History," in *Illuminations: Essays and Reflections*, trans. Harry Zohn (New York, NY: Schocken Books, 1969), 256.

285 Benjamin, "Theses on the Philosophy of History," 256.

286 Rammellzee, qtd. in Mark Bould, "The ships landed long ago: Afrofuturism and Black Science Fiction," *Science*

Fiction Studies, 34:2 (2007), 177-186.

287 Octavia E. Butler, *Kindred* (Boston, MA: Beacon Press, 2004).

288 Wilson Harris, "History, Fable, and Myth in the Caribbean and Guianas," in *Selected Essays of Wilson Harris: The Unfinished Genesis of the Imagination*, ed. A.J.M. Bundy (London: Routledge, 1999), 158.

289 Harris, "History, Fable, and Myth," 159.

290 Harris, "History, Fable, and Myth," 158-159.

291 John Akomfrah, dir., *The Last Angel of History*, Black Audio Film Collective, 1996.

292 Harris, "History, Fable, and Myth," 157.

293 Mati Diop, dir., *Atlantique*, Ad Vitam (France)/Netflix (worldwide), 2019.

294 Kamau Brathwaite, "Poetics, Revelations, and Catastrophes: An Interview with Kamau Brathwaite by Joyelle McSweeny," 2005, https://www.raintaxi.com/poetics-revelations-and-catastrophes-an-interview-with-kamau-brathwaite/

295 Loretta Collins, "From the 'Crossroads of Space' to the (dis)Koumforts of Home: Radio and the Poet as Transmuter of the Word in Kamau Brathwaite's 'Meridian' and Ancestors," *Anthurium: A Caribbean Studies Journal*, 1: 1 (2003), 12.

296 Kamau Brathwaite. *MR (Magical Realism), Volume 2* (New York, NY: Savacou North, 2002), 509.

297 Brathwaite, *MR (Magical Realism) Vol. 1*, 267.

298 For her poetic cosmological disruption please also see
 Alexis Pauline Gumbs on cataclysm, ancestors, specula-
 tion and magic in the *M Archive: After the End of the World*
 (Durham, NC: Duke University Press, 2018).

299 Frantz Fanon, *A Dying Colonialism*, trans. Haakon Cheva-
 lier (New York, NY: Grove Press, 1965).

300 Christina Sharpe, *In the Wake: On Blackness and Being*
 (Durham, NC: Duke University Press, 2016).

301 Sharpe, *In the Wake*, 20-21.

302 Sharpe, *In the Wake*, 3.

303 Sharpe, *In the Wake*, 11.

304 Sharpe, *In the Wake*, 18.

305 Édouard Glissant, *Poetics of Relation*, trans. Betsy Wing
 (Ann Arbor, MI: University of Michigan Press, 1997), 9.

306 Sharpe, *In the Wake*.

307 Sharpe, *In the Wake*, 15.

308 "Public Lecture by Nahum Dimitri Chandler," Depart-
 ment of Social and Cultural Analysis, New York Univer-
 sity, New York, NY, October 17, 2017, https://as.nyu.edu/
 departments/sca/events/spring-2017/public-lecture-by-na-
 hum-dimitri-chandler.html

309 "Public Lecture by Nahum Dimitri Chandler."

310 W.E.B. Du Bois, "The Forethought," in *The Souls of Black
 Folk: Essays and Sketches* (Chicago, IL: A.G. McClurg, 1903).

311 "Public Lecture by Nahum Dimitri Chandler."

312 Nahum Dimitri Chandler, "Of Exorbitance: The Problem of the Negro as a Problem for Thought," *Criticism* 50:3 (Summer 2008), 347.

313 Chandler, "Of Exorbitance," 351.

314 Ashon T. Crawley, *BlackPentecostal Breath: The Aesthetics of Possibility* (Bronx, NY: Fordham University Press, 2016).

315 Crawley, *BlackPentecostal Breath*.

316 Crawley, *BlackPentecostal Breath*.

317 Jane Bennett, *Influx & Efflux: Writing Up with Walt Whitman* (Durham, NC: Duke University Press, 2020), x.

318 Walt Whitman, Robert Hass, and Paul Ebankamp, *Song of Myself, and Other Poems* (Berkeley, CA: Counterpoint, 2010).

319 Bennett, *Influx & Efflux*, xxii.

320 Bennett, *Influx & Efflux*, x.

321 Bennett, *Influx & Efflux*, x.

322 Danielle Goldman, *I Want to Be Ready: Improvised Dance as a Practice of Freedom* Ann Arbor, MI: University of Michigan Press, 2010).

323 Sita Michelle Coltrane ("Alice Coltrane Turiyasangitananda"), "In the early 80s, my mother *Alice Coltrane Turiyasangitananda*, purchased land in the Santa Monica mountains on which she built an ashram with the lord's direction. She created a space for spiritual practice..." *Facebook*, November 17, 2018, https://www.

facebook.com/AliceColtraneOfficial/posts/in-the-early-80s-my-mother-alice-coltrane-turiyasangitananda-purchased-land-in-t/932128446970508/

324 Fred Moten, "Blackness and Nothingness (Mysticism in the Flesh)," *The South Atlantic Quarterly* 112(4), 2013, 768.

325 Sigal Samuel, "Why Cornel West Is Hopeful (But Not Optimistic)," *Future Perfect, Vox*, July 29, 2020, https://www.vox.com/future-perfect/2020/7/29/21340730/cornel-west-coronavirus-racism-way-through-podcast

326 Glissant, *Poetics of Relation*, 9.

327 K. Aarons, "No Selves to Abolish: Afropessimism, Anti-Politics, and the End of the World." *Mute Magazine.* February 29, 2016. https://www.metamute.org/editorial/articles/no-selves-to-abolish-afropessimism-anti-politics-and-end-world

328 Aarons, "No Selves to Abolish."

329 "Activated Negativity: An Interview with Marina Vishmidt," with Mira Mattar and Julia Calver, *Makhzin Issue 2: Feminisms*, April 1, 2016, http://www.makhzin.org/issues/feminisms/activated-negativity

Bibliography

Aarons, K. "No Selves to Abolish: Afropessimism, Anti-Politics, and the End of the World." *Mute Magazine*. February 29, 2016. https://www.metamute.org/editorial/articles/no-selves-to-abolish-afropessimism-anti-politics-and-end-world

Ades, Dawn, Fiona Bradley, and Paul Baker, eds. *Undercover Surrealism: Georges Bataille and* DOCUMENTS. Cambridge, MA: MIT Press, 2006.

Ahmed, Sara. *What's the Use? On the Uses of Use*. Durham, NC: Duke University Press, 2019.

Akomfrah, John dir. *The Last Angel of History*. Black Audio Film Collective, 1996.

Barad, Karen. "Diffracting Diffraction: Cutting Together-Apart." *Parallax* 20, no. 3 (2014): 168-187.

Barthes, Roland. *Camera Lucida: Reflections on Photography*. Translated by Richard Howard. New York, NY: Farrar, Straus, and Giroux, 1981.

Bataille, Georges. "Architecture," *Documents* 1, no. 2 (1929): 117; Reprinted in *Oeuvres Completes* Vol. 1, 172. Translated by Dominic Faccini. Paris: Gallimard, 1970.

Bataille, Georges. *Documents* 1, no. 7 (1929): 382; Reprinted in *Oeuvres Completes* Vol. 1, 80. Translated by Dominic Faccini. Paris: Gallimard, 1970.

Bataille, Georges. "Formless." *Documents* 1 (1929): 382; Reprinted in *Vision of Excess: Selected Writings, 1927-1939*. Translated by Allan Stoekl, Carl R. Lovitt, and Donald M. Leslie Jr. Minneapolis, MN: University of Minnesota Press, 1985.

Benjamin, Walter. *The Arcades Project*, third edition. Translated by Howard Eiland and Kevin McLaughlin. Cambridge, MA: Harvard University Press, 2002 (1982).

Benjamin, Walter. *Illuminations: Essays and Reflections*. Translated Harry Zohn. New York, NY: Schocken Books, 1969.

Bennett, Jane. *Influx & Efflux: Writing Up with Walt Whitman*. Durham, NC: Duke University Press, 2020.

Bennington, Geoffrey. "Embarrassing Ourselves." *Los Angeles Review of Books*. March 20, 2016: https://lareviewofbooks.org/article/embarrassing-ourselves/

Bois, Yve-Alain, and Rosalind Kraus, eds. *Formless: A User's Guide*. New York, NY: Zone Books, 1997.

Bould, Mark. "The ships landed long ago: Afrofuturism and Black Science Fiction." *Science Fiction Studies* 34, no. 2 (2007): 177-186.

boychild, Josh Johnson, and Total Freedom. *Untitled Duet (the storm called progress)*. Gropius Bau. Berlin. February 1-2, 2020.

boychild. Interviewed by the author, Hypatia Vourloumis, May 4, 2020.

Brathwaite, Kamau. *MR (Magical Realism), Volumes 1 & 2*. New York, NY: Savacou North, 2002.

Brathwaite, Kamau. "Poetics, Revelations, and Catastrophes: An Interview with Kamau Brathwaite by Joyelle McSweeny." 2005: https://www.raintaxi.com/poetics-revelations-and-catastrophes-an-interview-with-kamau-brathwaite/

Brathwaite, Kamau, and Nathaniel Mackey. *ConVERSations with Nathaniel Mackey*. New York: We Press, 1999.

Brown, Adrienne Maree. *Emergent Strategies: Shaping Change, Changing Worlds*. Chico, CA: AK Press, 2017.

Brown Jayna. "A Fierce Organicism: Ecologies of Enmeshment in Contemporary Speculative Art." Studium Genrale Academie Rietveld conference *Take A Walk on the Wild Side: Fabulating Critical Imaginaries in Art and Life*. Stedelijk Museum. Amsterdam, The Netherlands, March 30, 2019: https://youtu.be/u8MXDEOZL8E

Brown, Jayna. *Black Utopias: Speculative Life and the Music of Other Worlds*. Durham, NC: Duke University Press, *forthcoming*.

Brown, Ruth Nicole. *Hear Our Truths: The Creative Potential of Black Girlhood*. Champaign, IL: University of Illinois Press, 2013.

Butler, Octavia E. *Dawn*. New York, NY: Grand Central Publishing, 1997.

Butler, Octavia E. *Kindred*. Boston, MA: Beacon Press, 2004.

Butler, Octavia E. *Parable of the Sower*. New York, NY: Grand Central Publishing, 1993.

Callahan, Manuel. "In Defense of Conviviality and the Collective Subject." *Polis Revista Latinoamericana* 33 (2012): https://journals.openedition.org/polis/8432

Césaire, Aimé, Joan Pinkham, and Robin D.G. Kelley. *Discourse on Colonialism*. New York, NY: Monthly Review Press, 2001. Chandler, Nahum Dimitri. "Of Exorbitance: The Problem of the Negro as a Problem for Thought." *Criticism* 50, no. 3 (Summer 2008): 345-410.

Chlala, Youmna. *The Paper Camera*. Brooklyn, NY: Litmus Press, 2019.

Collins, Loretta. "From the 'Crossroads of Space' to the (dis) Koumforts of Home: Radio and the Poet as Transmuter of the Word in Kamau Brathwaite's 'Meridian' and Ancestors." *Anthurium: A Caribbean Studies Journal*, 1, no. 1 (2003): 1-18.

Coltrane, Sita Michelle ("Alice Coltrane Turiyasangitananda"). "In the early 80s, my mother *Alice Coltrane Turiyasangitananda*, purchased land in the Santa Monica mountains on which she built an ashram with the lord's direction. She created a space for spiritual practice...." *Facebook*. November 17, 2018: https://www.facebook.com/AliceColtraneOfficial/posts/in-the-early-80s-my-mother-alice-coltrane-turiyasangitananda-purchased-land-in-t/932128446970508/

Combahee River Collective Statement, April 1977: http://circuitous. org/scraps/combahee.html

Conant, Jeff. "What the Zapatistas Can Teach Us About the Climate Crisis." *Foreign Policy in Focus*. August 3, 2010: https://fpif.org/ what_the_zapatistas_can_teach_us_about_the_climate_crisis/

Crawley, Ashon T. *Blackpentecostal Breath: The Aesthetics of Possibility*. Bronx, NY: Fordham University Press, 2016.

Davis, Vaginal, N-Prolenta, ¥€$Si PERSE, and Urami. *Cherish x Queer Is Not A Label*. Route de Saint-George 51, Geneva, Switzerland. March 13-14, 2020.

Derrida, Jacques. *Margins of Philosophy*. Translated by Alan Bass. Chicago, IL: University of Chicago Press, 1982.

Derrida, Jacques. *Positions*. Translated by Alan Bass. Chicago, IL: University of Chicago Press, 1981.

Derrida, Jacques. *Speech and Phenomena, And Other Essays on Husserl's Theory of Signs*. Translated by David B. Allison. Evanston, IL: Northwestern University Press, 1973.

Dick, Kirby, and Amy Ziering dirs. *Derrida*. 2002; Jane Doe Films.

Diop, Mati dir. *Atlantique*. Ad Vitam (France)/Netflix (worldwide), 2019.

Du Bois, W.E.B. "Sociology Hesitant." *boundary 2* 27, no. 3 (Fall 2000): 37-44.

Du Bois, W.E.B. *The Souls of Black Folk: Essays and Sketches.* Chicago, IL: A.G. McClurg, 1903.

Edwards, Brent Hayes. *Epistrophies: Jazz and the Literary Imagination.* Cambridge, MA: Harvard University Press, 2017.

Ellison, Ralph. *Invisible Man.* New York, NY: Random House, 1952.

Elmer, Greg dir. *The Politics of Preemption.* Art & Education. October 2019: https://www.artandeducation.net/classroom/video/294555/randy-martin-the-politics-of-preemption

Escarfuller, Wilda. "[i]AQ[/i] Interview: Rita Indiana Captivates Merengue Fans in New York City." *Americas Quarterly.* July 10, 2011: https://www.americasquarterly.org/article/iaq-i-inter-view-rita-indiana-captivates-merengue-fans-in-new-york-city/

Eshun, Kodwo. "Feminism: Possibilities for Knowing, Doing, and Existing. A Conversation Between the Otolith Group and Annie Fletcher." *L'Internationale Online.* June 24, 2018: https://www.internationaleonline.org/research/politics__of__life__and__death/107__feminism__possibilities__for__know-ing__doing__and__existing__a__conversation__between__the__otolith__group__and__annie__fletcher/

Fanon, Frantz. *A Dying Colonialism.* Translated by Haakon Chevalier. New York, NY: Grove Press, 1965.

Fanon, Frantz. *The Wretched of the Earth.* Translated by Richard Philcox. New York, NY: Grove Atlantic, 2007 (1961).

Ferreira da Silva, Denise. "On Difference Without Separability." *32nd Bienal De São Paulo Art Biennial: Incerteza viva*. 2016: 57-65.

"Fred Moten with Jarrett Earnest." *The Brooklyn Rail: Critical Perspectives on Art, Politics, and Culture.* November 2017: https://brooklynrail.org/2017/11/art/FRED-MOTEN-with-Jarrett-Earnest

"From Cooperation to Black Operation: A Conversation with Stefano Harney and Fred Moten on *The Undercommons*." *Transversal Texts*. April 2016: https://transversal.at/blog/From-cooperation-to-black-operation

Foucault, Michel. *Discipline and Punish: The Birth of the Prison*. Translated by Alan Sheridan. New York, NY: Knopf Doubleday, 2012 (1975).

Freeman, Jo. "The Tyranny of Structurelessnes." *Struggle*. 2000 (1970): http://struggle.ws/pdfs/tyranny.pdf

Gibson, William. "Books of the Year." *The Economist*. December 4, 2003.

Glissant, Édouard. *Poetics of Relation*. Translated by Betsy Wing. Ann Arbor, MI: University of Michigan Press, 1997.

Goldman, Danielle. *I Want to Be Ready: Improvised Dance as a Practice of Freedom*. Ann Arbor, MI: University of Michigan Press, 2010.

Gopinath, Gayatri. *Unruly Visions: The Aesthetic Practices of Queer Diaspora*. Durham, NC: Duke University Press, 2018.

Gressman, Erica. *COVID-19*. The Quarantine Concerts. Experimental Sound Studio. Chicago, IL, April 1, 2020: https://www.youtube.com/watch?v=FsyFD-xjeRo&t=5s

Gressman, Erica. *Wall of Skin*. Channing Murray Foundation. Urbana, IL. April 7, 2016.

Guattari, Félix. "Machine et Structure." In *Psychanalyse et transversalité: Essais d'analyse institutionelle* Paris: La Découverte, 2003.

Gumbs, Alexis Pauline. *M Archive: After the End of the* World. Durham, NC: Duke University Press, 2018.

Harris, Laura. *Experiments in Exile: C. L. R. James, Hélio Oiticica, and the Aesthetic Sociality of Blackness*. New York, NY: Fordham University Press, 2018.

Harris, Wilson. "History, Fable, and Myth in the Caribbean and Guianas." In *Selected Essays of Wilson Harris: The Unfinished Genesis of the Imagination*. Edited by A.J.M. Bundy, 152-166. London: Routledge, 1999.

Harris, Wilson. "The Unfinished Genesis of the Imagination." *The Journal of Commonwealth Literature* 27, no. 1 (March 1, 1992): 13-25.

Harney, Stefano and Fred Moten. *The Undercommons: Fugitive Planning & Black Study*. Brooklyn, NY: Autonomedia/Minor Compositions, 2013.

Harvey, David. "Marx's Refusal of the Labour Theory of Value." *Reading Marx's Capital with David Harvey*. March 14, 2018: http://davidharvey.org/2018/03/marxs-refusal-of-the-labour-theory-of-value-by-david-harvey/

hooks, bell. "An Aesthetic of Blackness: Strange and Oppositional." *Lenox Avenue: A Journal of Interarts Inquiry*, Vol. 1 (1995): 65.

The Invisible Committee. *The Coming Insurrection*. Cambridge, MA: MIT Press, 2007.

The Invisible Committee. *Now*. Translated by Robert Hurley. Cambridge, MA: MIT Press, 2017.

Iyer, Vijay. "Exploding the Narrative in Jazz Improvisation." In *Uptown Conversation: The New Jazz Studies*. Edited by Robert G. O'Meally, Brent Hayes Edwards, and Farah Jasmine Griffin, 393-403. New York, NY: Columbia University Press, 2004.

Jaime, Karen. "Da pa' lo' do' ": Rita Indiana's Queer, Racialized Dominicanness" *Small Axe* 19, no. 2 (2015): 85-93.

Jameson, Frederick. *Postmodernism, Or, the Cultural Logic of Late Capitalism*. Durham, NC: Duke University Press, 1991.

Jemisin, N.K. *The Fifth Season*. London: Orbit, 2015.

Kapadia, Ronak K. *Insurgent Aesthetics: Security and the Queer Life of the Forever War*. Durham, NC: Duke University Press, 2019.

Kelley, Robin D.G. "A Poetics of Anticolonialism." In *Discourse on Colonialism*, 7-28. New York, NY: Monthly Review Press, 2001.

Las Tesis. "Un Violador En Tu Camino." Performed on International Day for the Elimination of Violence Against Women. Santiago, Chile. November 25, 2019.

Leonardo, Engel dir. *Da Pa Lo Do*. Performed by Rita Indiana y Los Misterios. Premium Latin Music, 2010: https://www.youtube.com/watch?v=Y72XAybPTnU

Lewis, Ligia, Jonathan Gonzalez, Hector Thami Manekehla, and Tiran Willemse. *minor matter*. HAU Hebbel am Ufer. Berlin. November 24-27, 2016.

Linebaugh, Peter, and Marcus Rediker. *The Many-Headed Hydra: Sailors, Slaves, Commoners, and the Hidden History of the Revolutionary Atlantic*. New York, NY: Verso Books, 2012.

Lock, Graham. *Blutopia: Visions of the Future and Revisions of the Past in the Work of Sun Ra, Duke Ellington, and Anthony Braxton*. Durham, NC: Duke University Press, 1999.

Lothian, Alexis. *Old Futures: Speculative Fiction and Queer Possibility*. New York, NY: NYU Press, 2018.

Mackey, Nathaniel. *Discrepant Engagement: Dissonance, Cross-Culturality, and Experimental Writing*. Cambridge: Cambridge University Press, 1993.

Maldonado-Vélez, S.G. "Erica Gressman." *La Estación Gallery Podcast*. November 8, 2019: https://soundcloud.com/user-605923905/erica-gressman

Man, Simeon, A. Naomi Paik, and Melina Pappademos. "Violent Entanglements: Militarism and Capitalism." *Radical History Review* 133 (January 2019): 1-10.

"Manos Danezis with George Sachinis." *Antithesis*. CreteTV. May 13, 2017: https://www.youtube.com/watch?v=yzvFT-PM21bs&t=196s

Marx, Karl. *Capital: A Critique of Political Economy Vol. 1*. Edited by Frederick Engels. Translated by Samuel Moore and Edward Aveling. Moscow: Progress Publishers, 1887.

Mattar, Mira, and Julia Calver. "Activated Negativity: An Interview with Marina Vishmidt." *Makhzin Issue 2: Feminisms*. April 1, 2016: http://www.makhzin.org/issues/feminisms/activated-negativity

McKittrick, Katherine. "Axis, Bold as Love." In *Sylvia Wynter: On Being Human as Praxis*, 142-163. Durham, NC: Duke University Press, 2015.

"Michio Kaku: Are There Extra Dimensions?" *Closer to Truth*. January 29, 2016: https://youtu.be/RUlVFzl__BJs

"Michio Kaku: The Multiverse Has 11 Dimensions." *Big Think*. May 31, 2011: https://youtu.be/jI50HN0Kshg

"Michio Kaku: The Universe Is a Symphony of Vibrating Strings." *Big Think*. May 31, 2011: https://youtu.be/fW6JFKgbAF4

Mirzoeff, Nick. "Boggs Standard Time – in Detroit and Beyond." *Waging Nonviolence*. January 27, 2014: https://wagingnonviolence. org/2014/01/boggs-standard-time-detroit-beyond/

Moten, Fred. "Blackness and Nothingness (Mysticism in the Flesh)." *The South Atlantic Quarterly* 112, no. 4 (2013): 737-780.

Moten, Fred. *In the Break: The Aesthetics of the Black Radical Tradition*. Minneapolis, MN: University of Minnesota Press, 2003.

Moten, Fred. *Black and Blur*. Durham, NC: Duke University Press, 2017.

Moten, Fred. *The Universal Machine*. Durham, NC: Duke University Press, 2018.

Moussawi, Ghassan. *Disruptive Situations: Fractal Orientalism and Queer Strategies in Beirut*. Philadelphia, PA: Temple University Press, 2020.

Moved by the Motion. *Sudden Rise*. Whitney Museum of American Art. New York, NY. April 26-27, 2019.

Mugge, Robert dir. *Sun Ra: A Joyful Noise*. 1980.

Muller, Sophie dir. *Soldier of Love*. Performed by Sade. RCA Records, 2010.

Muñoz, José Esteban. "'Chico, what does it feel like to be a problem?': The Transmission of Brownness." In *A Companion to Latina/o Studies*. Edited by Juan Flores and Renato Rosaldo, 441-451. Malden, MA: Blackwell Publishing, 2007.

Muñoz, José Esteban. *Disidentifications: Queers of Color and the Performance of Politics*. Minneapolis, MN: University of Minnesota Press, 1999.

Muñoz, José Esteban. "Ephemera as Evidence: Introductory Notes to Queer Acts." *Women & Performance: A Journal of Feminist Theory* 8, no. 2 (1996): 5-16.

Muñoz, José Esteban. "Vitalism's After-Burn: The Sense of Ana Mendieta." *Women & Performance: A Journal of Feminist Theory* 21, no. 2 (July 2011): 191-198.

Ngô, Fiona, Joshua Chambers-Letson, and Sandra Ruiz. Conversation following Erica Gressman's *Limbs*. Krannert Art Museum. Champagne, IL. September 13, 2018.

Nguyen, Patricia. "Building a Monumental Anti-Monument: The Chicago Torture Justice Memorial." *The Funambulist.* 2019: https://thefunambulist.net/articles/building-a-monumental%E2%80%A8anti-monument-the-chicago-torture-justice-memorial-by-patricia-nguyen

Nguyen, Patricia. "Statement." *The Funambulist.* 2019: 46.

Nguyen, Patricia. *Echoes*. Exhibit: *Upheavals*. Defibrillator Gallery + Zhou B Art Center. Chicago, IL. September 2019.

Nguyen, Patricia. *Untitled*. Exhibit: *Groundlings*. Museum of Contemporary Art. Chicago, IL. March 2019;

Oliveros, Pauline. *Deep Listening: A Composer's Sound Practice*. Lincoln, NE: iUniverse, 2005.

"Pauline Oliveros: Still Listening!" *Deep Listening Institute*, *https://www.deeplistening.org*

Paulson, Steve. "Critical Intimacy: An Interview with Gayatri Chakravorty Spivak." *Los Angeles Review of Books*. July 29, 2016: https://lareviewofbooks.org/article/critical-intimacy-interview-gayatri-chakravorty-spivak/

"Public Lecture by Nahum Dimitri Chandler." Department of Social and Cultural Analysis. New York University, New York, NY. October 17, 2017: https://as.nyu.edu/departments/sca/events/spring-2017/public-lecture-by-nahum-dimitri-chandler.html

Quintero, Noelia dir. *La Hora de Volve*. Performed by Rita Indiana y Los Misterios. Premium Latin Music, 2010.

R.E.M. "It's the End of the World as We Know It (And I Feel Fine)." *Document*. I.R.S. 1987.

Ra, Sun. "We Hold This Myth To Be Potential (1980)." In *The Immeasurable Equation: The Collected Poetry and Prose*. Edited by James L. Wolf and Hartmut Geerken, 420. Wartaweil, Germany: WAITAWHILE, 2005.

Ra, Sun. *The Planet is Doomed*. New York, NY: Kicks Books, 2011.

Raji, Remi. *Gather My Blood Rivers of Song*. Ibadan: Diktaris, 2009.

"Rethinking the Apocalypse: An Indigenous Anti-Futurist Manifesto." *Indigenous Action*. March 19, 2020: http://www.indigenousaction.org/rethinking-the-apocalypse-an-indigenous-anti-futurist-manifesto/

Rita Indiana y Los Misterios. "La Hora de Volve." *El Juidero*. Premium Latin Music, 2010.

Rivera, Sylvia. "Y'all Better Quiet Down." Christopher Street Liberation Day rally. Washington Square Park, New York, NY, 1973.

Robinson, Cedric. *The Terms of Order: Political Science and the Myth of Leadership*. Chapel Hill, NC: University of North Carolina Press, 2016.

Rosa, Hartmut. *Resonance: A Sociology of Our Relationship to the World*. Translated by J. Wagner. Cambridge, MA: Polity, 2019.

Rossiter, Ned, and Soenke Zehle. "Acts of Translation: Organizing Networks as Algorithmic Technologies of the Common." *NedRossiter.org*. April 27, 2013: https://nedrossiter.org/?p=332

Ruiz, Sandra. "Organismal Futurisms in Brown Sound and Queer Luminosity: Getting into Gressman's Cyborgian Skin." *Performance Matters* 3, no. 2 (2017): 72-91.

Ruiz, Sandra. *Ricanness: Enduring Time in Anticolonial Performance.* New York, NY: NYU Press, 2019.

Sade. "Soldier of Love." *Soldier of Love.* New York, NY: RCA Records, 2010.

Samuel, Sigal. "Why Cornel West Is Hopeful (But Not Optimistic)." Future Perfect. *Vox.* July 29, 2020: https://www.vox.com/future-perfect/2020/7/29/21340730/cornel-west-coronavirus-racism-way-through-podcast

Sankara, Thomas. "A United Front Against Debt." *Viewpoint.* February 1, 2018: https://www.viewpointmag.com/2018/02/01/united-front-debt-1987/

Scott, David. "The re-enchantment of humanism: An interview with Sylvia Wynter." *Small Axe: A Caribbean Journal of Criticism*, 4, no. 2 (2000): 119-207.

Sedgwick, Eve Kosovsky. *Tendencies.* Durham, NC: Duke University Press, 1993.

Sharpe, Christina. *In the Wake: On Blackness and Being.* Durham, NC: Duke University Press, 2016.

Shukaitis, Stevphen. *The Compositions of Movements to Come: Aesthetics and Cultural Labor after the Avant-Garde.* Lanham, MD: Rowman & Littlefield, 2015.

Simpson, Audra. *Mohawk Interruptus: Political Life Across the Borders of Settler States.* Durham, NC: Duke University Press, 2014.

Steinmetz, Julia. "In Recognition of Their Desperation: Sonic Relationality and the Work of Deep Listening." *Studies in Gender and Sexuality* 20, no. 2 (2019): 119-132.

Stoler, Ann Laura. *Imperial Debris: On Ruins and Ruination.* Durham, NC: Duke University Press, 2013.

Story in the Public Square: Season 3. The Pell Center. Newport, RI. October 21, 2019: https://www.youtube.com/watch?v=QG-pGb67mfto

Summer, Donna. "I Feel Love." *I Remember Yesterday.* Casablanca, 1977.

Sun Ra Arkestra. "Nuclear War." Y Records: 1982.

Sun Ra Arkestra. *Sunrise in Different Dimensions.* hat HUT, 1980.

Susen, Simon. "The Resonance of Resonance: Critical Theory as a Sociology of World-Relations?" *International Journal of Politics, Culture, and Society* 33, no. 3 (2020): 309-344.

Tsang, Wu. "There Is No Non-Violent Way to Look at Somebody." Gropius Bau. Berlin. September 4, 2019 - January 12, 2020.

Tsang, Wu, and Fred Moten. "Sudden Rise at a Given Tune." *South Atlantic Quarterly* 117, no. 3 (2018): 649-652.

Tsang, Wu dir. *One emerging from a point of view.* Sharjah Art Foundation and Onassis Fast Forward Festival 6. Athens, Greece. May 5-19, 2019.

Tsang, Wu dir. *We hold where study*. The Modern Women's Fund. MoMA. New York, NY. 2017.

Tsang, Wu dir. *Wildness*. Class Productions, 2012.

Tuck, Eve, and K. Wayne Yang. "Decolonization Is Not a Metaphor." *Decolonization: Indigeneity, Education & Society* 1, no. 1 (2012): 1-40.

Vaginal Davis, N-Prolenta, ¥€$Si PERSE, and Urami. *Cherish x Queer Is Not A Label*. Route de Saint-George 51, Geneva, Switzerland. March 13-14, 2020.

Vazquez, Alexandra T. *Listening in Detail: Performances of Cuban Music*. Durham, NC: Duke University Press, 2013.

Vo, Anh. "On Blackness – Ligia Lewis: Minor Matter (2016)." *Cult Plastic: Dance and Culture in the Plastic Age*. June 26, 2017: https://cultplastic.com/2017/06/26/on-blackness-ligia-lewis-minor-matter-2016/

Vourloumis, Hypatia. "Ten Theses on Touch, or, Writing Touch." *Women & Performance*. February 2, 2015: https://www.womenandperformance.org/ampersand/ampersand-articles/ten-theses-on-touch-or-writing-touch-hypatia-vourloumis.html

Vuong, Ocean. *On Earth We're Briefly Gorgeous*. New York, NY: Penguin Press, 2019.

Whitman, Walt, Robert Hass, and Paul Ebankamp. *Song of Myself, and Other Poems*. Berkeley, CA: Counterpoint, 2010.

Williams, Raymond. *Keywords: A Vocabulary of Culture and Society*. Oxford: Oxford University Press, 2014.

Wynter, Sylvia. "The Pope Must Have Been Drunk, the King of Castile a Madmen: Culture as Actually and the Caribbean Rethinking of Modernity." In *Reordering of Culture: Latin America, the Caribbean and Canada in the 'Hood*. Edited by A. Ruprecht and C. Taiana, 17-41. Ottawa: Carleton University Press, 1995.

Wynter, Sylvia. "Unsettling the Coloniality of Being/Power/Truth/Freedom: Towards the Human, After Man, Its Overrepresentation – An Argument." *CR: The New Centennial Review* 3, no. 3 (Fall 2003): 257-337.

Wynter, Sylvia, and Katherine McKittrick. "Unparalleled Catastrophe for Our Species? Or, to Give Humanness a Different Future: Conversations." In *Sylvia Wynter: On Being Human as Praxis*. Edited by Katherine McKittrick, 9-89. Durham, NC: Duke University Press, 2015.

CPSIA information can be obtained
at www.ICGtesting.com
Printed in the USA
JSHW020430290521
15330JS00001B/20

9 781570 273797